IN FOCUS

ALFRED STIEGLITZ

PHOTOGRAPHS

from

THE J. PAUL GETTY MUSEUM

The J. Paul Getty Museum

Malibu, California

In Focus
Photographs from the J. Paul Getty Museum
Weston Naef, *General Editor*

© 1995 The J. Paul Getty Museum
17985 Pacific Coast Highway
Malibu, California 90265-5799

Christopher Hudson, *Publisher*
Mark Greenberg, *Managing Editor*

Library of Congress
Cataloging-in-Publication Data

Stieglitz, Alfred, 1864–1946.
 Alfred Stieglitz : photographs from the J. Paul
Getty Museum.
 p. cm. — (In focus)
 ISBN 0-89236-303-7
 1. Photography, Artistic. 2. Stieglitz, Alfred,
1864–1946. 3. J. Paul Getty Museum—Photograph
collections. 4. Photograph collections—California—
Malibu. I. J. Paul Getty Museum. II. Title.
III. Series: In focus (J. Paul Getty Museum)
TR653.S782 1995
779'.092—dc20 95-22818
 CIP

Alfred Stieglitz photographs reproduced in agree-
ment with the Estate of Georgia O'Keeffe.

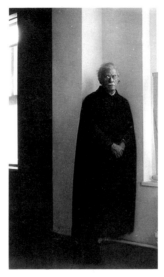

Dorothy Norman. *Alfred Stieglitz,* 1930s.
Gelatin silver print, 9 × 5.3 cm.
84.XM.895.5.

Editor	Gregory A. Dobie
Designer	Jeffrey Cohen
Production Coordinator	Stacy Miyagawa
Photographer	Ellen Rosenbery
Printer	The Stinehour Press
	Lunenburg, Vermont
Bindery	Roswell Book Bindery
	Phoenix, Arizona

(pictures by Ansel Adams and Eliot Porter the only new photographic work shown).

1932
First solo exhibition since 1923 held at An American Place (127 prints dating from 1892 to 1932).

1933
Makes gift to the Metropolitan Museum of Art of over one thousand photographs, paintings, drawings, and prints by more than one hundred different artists.

1934
The book *America and Alfred Stieglitz: A Collective Portrait,* edited by Waldo Frank, is published to commemorate Stieglitz's seventieth birthday. Final one-man exhibition held at An American Place (sixty-nine prints dating from 1884 to 1934).

1935
Donates a small group of his photographs to the Cleveland Museum of Art in honor of Carey Welch.

1936
Moves with O'Keeffe to 405 East Fifty-fourth Street.

1937
Makes the last of his photographs.

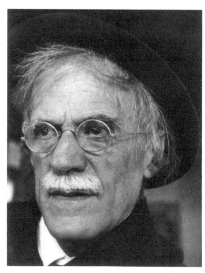

Dorothy Norman. *Alfred Stieglitz,* 1932. Gelatin silver print, 9.5 × 7.4 cm. 84.XM.895.3.

1941
Museum of Modern Art, New York, acquires a group of Stieglitz's photographs. Reunion with Steichen after a twenty-year feud.

1942
Moves with O'Keeffe to 59 East Fifty-fourth Street.

1946
Dies July 13 at Doctors' Hospital in New York.

Contents

Foreword

Few names in the history of photography are as well known as that of Alfred Stieglitz, whose pictures were the first to be collected by American art museums as complements to existing collections of prints, drawings, and illustrated books. In 1924 the Museum of Fine Arts, Boston, acquired twenty-seven photographs; four years later the Metropolitan Museum of Art acquired twenty-three. In 1949, at the direction of his widow, Georgia O'Keeffe, the National Gallery of Art received sixteen hundred photographs from Stieglitz's estate, and for nearly forty years Stieglitz was the only photographer represented in the Gallery's collection. When the J. Paul Getty Museum's Department of Photographs was established in 1984, the new holdings included sixty-two Stieglitz photographs from various sources, including Samuel Wagstaff, Jr., Arnold Crane, and Daniel Wolf. Since then, important examples have been bought individually and in groups. The opportunity to acquire eighty Stieglitz photographs from the estate of Georgia O'Keeffe gave us a collection second only to that of the National Gallery.

The text of this book is drawn from a discussion of Stieglitz's life and art held on October 5, 1993, at the Grolier Club in New York City. I want to thank the participants— Emmet Gowin, Sarah Greenough, Weston Naef, and John Szarkowski—for their spirited and informative remarks, and the moderator, Charles Hagen, for his skill in guiding the session and editing the transcript.

We are grateful to the Grolier Club for its hospitality and to Martin Antonetti, librarian; William McClure, business manager; and the staff of the club for their assistance (as well as to Melvin Simmons, sound engineer, and Ted Panken, transcriber). In our Department of Photographs, Katherine Ware, Assistant Curator; Julian Cox, Curatorial Assistant; Michael Hargraves, cataloger; and Marcia Lowry, Staff Assistant, assisted in research and logistics. We are indebted as well to Elizabeth Glassman, William Homer, Sue Davidson Lowe, Barbara Lynes, and Sarah Peters for providing information about Stieglitz's life and work.

John Walsh, *Director*

4

Introduction

Alfred Stieglitz (1864–1946) remains as one of the most dominant individuals in the history of photography. His importance results not only from the quality of his photographs but also from the extraordinary regard he gave to works created by others. Stieglitz discovered and promoted many artists in the exhibitions he organized, publications he edited, and collections he formed. He is unusual in the history of art for having been highly influential on both sides of the equation that puts the creation of art opposite its consumption. In his roles as photographer, publisher, writer, impresario, and collector he passed through several phases that reflected his growth and development as an individual. Each of these activities had its own cast of players with whom Stieglitz prolifically communicated in writing. The bulk of his correspondence is housed at Yale University, an archive that has been the chief source of information for the texts opposite the plates.

Stieglitz advanced into young adulthood with a love of music—the piano was his instrument—and a talent for science. He commenced engineering studies at the Technische Hochschule in Berlin in 1882. The following year he discovered photography, and given his background, it is not surprising that he gravitated first to its chemistry and optics as subjects for study. In Berlin he was fortunate to have as his teacher one of the most inventive photochemists in the entire field, Professor Hermann Wilhelm Vogel, who devised a way for negatives to record in black and white on one sheet of film a balanced spectrum of light from blue to near red.

Stieglitz applied the skills he learned with tireless experimentation, and soon his pictures were being accepted for exhibitions and awarded prizes for their quality. He was praised by such elders of photography as Peter Henry Emerson, whose books and photographs defined the style called Naturalism. Stieglitz shared with Emerson a belief that nature was the fountainhead of all art and that the artist's job was to express not just surface appearance but also underlying structure. Stieglitz absorbed the principles espoused by Emerson in his book *Naturalistic Photography for Students of the Art* (1889) in works like *Weary* (pl. 1), dating from 1890.

Among the skills Stieglitz learned in Europe was the craft of reproducing photographs mechanically on printing presses for use in books and magazines. Berlin was a center of the photomechanical printing industry, and the Technische Hochschule, where he was enrolled, was one of the chief teaching institutions. High-quality printing became central to disseminating Stieglitz's vision, both in the periodicals to which he contributed, such as *American Amateur Photographer* (1893–96), and especially later in the journals he founded: *Camera Notes* (1897–1902) and *Camera Work* (1903–17).

While he was living in Europe after his student years, Stieglitz attended the 1889 Jubilee exhibition in Vienna celebrating the fiftieth anniversary of the public announcement of photography. There he saw for the first time the work of the old masters of the medium, including Louis-Jacques-Mandé Daguerre, William Henry Fox Talbot, and Julia Margaret Cameron, which was his introduction to the history of photography before Emerson. In the mid-1890s he also saw exhibitions organized by the Photo Club of Paris and the Linked Ring in London, and they taught him how effective exhibitions are to the understanding of art. After returning to the United States, he was responsible for initiating a number of pioneering exhibitions at the Camera Club of New York, the National Arts Club (where the name Photo-Secession was coined in 1902), and The Little Galleries of the Photo-Secession (1905–17), later known as 291 (for its location on Fifth Avenue). Stieglitz's role in creating such exhibition spaces as 291 (pl. 12) was so prescient that numerous photographers and artists received their first solo exhibitions anywhere under his direction, most notably Picasso in 1911. Among the American painters with whom his name will be forever linked because of his sup-

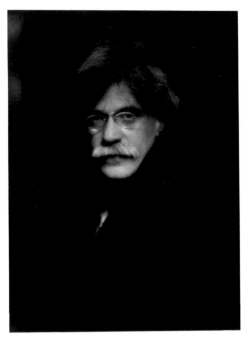

Alfred Stieglitz. *Self-Portrait*, 1907.
Gelatin silver print, 24.8 × 18.4 cm.
93.XM.25.38.

port over a period of decades are John Marin, Marsden Hartley, Arthur Dove, and Georgia O'Keeffe.

Virtually all of the exhibitions that Stieglitz organized included works that were for sale. He bought art directly from the makers and over a period of thirty years acquired more than one thousand photographs, prints, drawings, and paintings by dozens of individuals, some of the works the first ever sold by the artists.

While Stieglitz's place in history is assured, Stieglitz the man is more elusive, for behind all his achievements there was a dark side to his personality that confounded his family and closest friends. He was a complex man with many facets who believed that it was useless merely to record the surfaces of objects— people, buildings, trees, clouds—unless they were understood. To understand requires great sensitivity to the complexity of relations among elements, and it is in

the expression of these often-concealed relationships that Stieglitz excelled. Notoriously insensitive to the feelings of other people, however, he had a reputation for being a tyrant, whose redemption was the high esteem in which his cause was held even by his opponents.

The contents of this book have been selected to represent the diverse aspects of Stieglitz's art. The guiding idea has been to include many photographs that have not been frequently seen in the context of some of his best-known pictures. Like most artists, Stieglitz created a body of work that can be categorized broadly as pictures that were intended for an audience and made public soon after being created, pictures that were never exhibited for circumstantial reasons, and pictures that were highly personal and not destined for public consumption.

Stieglitz reluctantly released his work for exhibition and publication by others, generally doing so only when he was in full control of the exhibition or publication. He was a persistent experimenter when it came to making prints, and he mastered most of the chief processes of his time: hand-printed photogravure, autochrome, platinum, palladium, and finally, gelatin silver. The variety of materials he used can be accounted for in part by his desire to see how the negatives responded to them, but there were also circumstances outside of his control. Manufacturers of photographic materials changed their products as the result of market conditions, and he was forced to abandon, for example, platinum and palladium printing because the products were discontinued. He expressed his approach in a 1920 letter to a friend: "All I know about myself is that I am an honest workman.—And that good workmanship is ever a passion with me.—And as I age the passion becomes more intense. Borders on mania." Stieglitz, however, was not an obsessed technician and always placed content equal to form in his scale of values. Toward the end of his life he summarized his philosophy in a letter to James Thrall Soby: "If what I feel about life is not in a print of mine, then I might just as well say that any machine can take a picture and turn out a print mechanically. You might get wonderful pictures as a result, but they would not contain that something called love or passion, both of which are the essentials needed to bring forth a living print—or any other living creative expression."

Weston Naef, *Curator, Department of Photographs*

Plates

PLATE I

Weary

1930s gelatin silver print
from an 1890 negative
15.4 × 21.3 cm
93.XM.25.56

Born in Hoboken, New Jersey, on Janu-
ary 1, 1864, of German-American parents,
Alfred Stieglitz was raised in New York City
in relative prosperity. He returned to his
parents' homeland in 1881 and enrolled in
Karlsruhe's Realgymnasium, a secondary
school specializing in science, where he
also brushed up on his German. Two years
later, after having relocated to Berlin to
continue his studies, he acquired his first
camera and experimented with the wet col-
lodion process before shifting to the new
dry-plate methods. He was an avid outdoors-
man and by 1884 had walked more than five
hundred miles in the Austrian and Swiss
Alps, making landscape and genre studies.
This inspired him to take photography
much more seriously than he had before.
He began to enter his pictures into contests
sponsored by photography publications,
and his work soon earned him recognition
from experts in the field. He was awarded
a traveling fellowship by the *Amateur
Photographer* that partly financed his travels
in France in 1890, where he may have made
this study of a young girl. His career in
photography was fully confirmed when he
won a gold medal for another image made
on the same trip. The choice of subject and
composition in *Weary* suggests that Stieglitz
was influenced by artists of the Karlsruhe
school, whose vocabulary was a somewhat
mechanically realized late Impressionism.

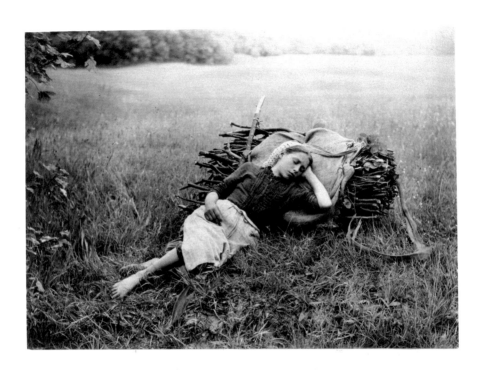

PLATE 2

The Terminal

1915 photogravure
from an 1893 negative
25.4 × 33.5 cm
84.XM.695.23

Stieglitz returned to New York from Germany at his father's request in the fall of 1890 to begin a career in the graphic arts business. Edward Stieglitz had bought his son an ownership interest in a new enterprise that specialized in photochemically preparing high-quality copper plates for use by printers to incorporate reproductions of paintings and photographs with letterpress texts in publications. The enterprise was located at 162 Leonard Street in lower Manhattan, where an explosion of building activity for skyscrapers, subways, and other urban projects made the locale the antithesis of the picturesque Europe from which he had just returned after spending almost a decade there.

In late 1892 he began to prowl the streets prospecting for worthwhile subjects. Five years before Eugène Atget made his first studies of street vendors and trolleys in Paris, Stieglitz realized that the city of New York was full of promising motifs. "From 1893 to 1895 I often walked the streets of New York downtown, near the East River, taking my hand camera with me. I wandered around the Tombs [jailhouse], the old Post Office, Five Points. I loathed the dirty streets, yet I was fascinated. I wanted to photograph everything I saw," he recounted to a friend. Stieglitz had begun to make his photographs much more self-expressive than they had been to this point.

"[One day] I found myself in front of the old Post Office. The Third Avenue street railway and the Madison Avenue car systems had their terminals there, opposite the old Astor House. It was extremely cold. Snow lay on the ground. A driver in a rubber coat was watering his steaming car horses. How fortunate the horses seemed, having a human being to tend them. . . . The steaming horses being watered on a cold winter day, the snow-covered streets . . . [expressed] my own sense of loneliness in my own country," Stieglitz reminisced about a picture that portended his great achievement in *The Steerage* (pl. 6) about a dozen years later.

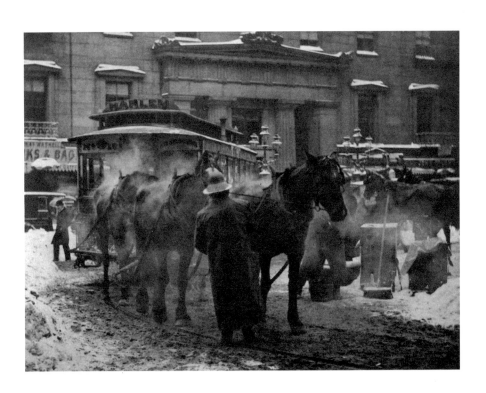

PLATE 3

A Venetian Canal

1930s gelatin silver print
from an 1894 negative
21.7 × 16.3 cm
93.XM.25.55

Stieglitz married Emmeline Obermeyer just before Thanksgiving of 1893 in a grand ceremony and gala reception at Sherry's, one of the most exclusive restaurants in New York. His bride—the sister of his Berlin roommate Joseph Obermeyer, who had just become one of his partners in the Photochrome Engraving Company—was ten years younger than Stieglitz and held him in awe for his worldliness and achievements in photography. The couple moved into an apartment at the Savoy Hotel and in the summer of 1894 took a four-month honeymoon tour of Europe, which gave Stieglitz the chance to introduce Emmeline to some of his favorite places. He was extremely fond of Italy, especially Venice. The Venetian canals represented for him the total merging of opposite qualities that attracted him:

light versus dark, structure versus fluidity, decay versus growth. His wife thought that the canals' smells and sounds were ugly. This 1894 study may express the melancholy Stieglitz was experiencing from his first realization that he and Emmeline were motivated by quite different priorities.

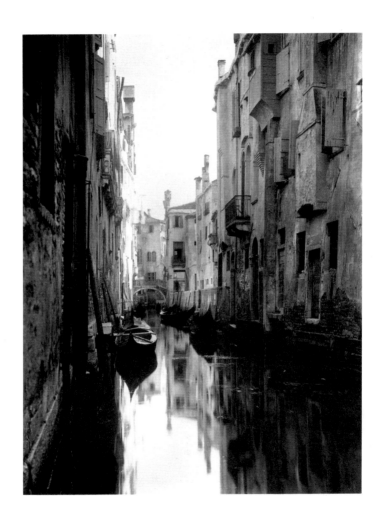

PLATE 4

The Hand of Man

1930s gelatin silver print
from a 1902 negative
8.3 × 11.2 cm
93.XM.25.7

The decade that elapsed between the making of *A Venetian Canal* (pl. 3) and *The Hand of Man* saw the key elements of Stieglitz's destiny fall into place. He was one of the principals in the 1896 reorganization of New York's two competing societies of amateur photographers into a single unit, the Camera Club of New York, and the founding editor of its new journal, *Camera Notes.* Under his guidance the periodical became the venue for the best American and European photography, reproduced in high-quality gravures by the Photochrome Engraving Company.

He also became active in organizing international exhibitions of photographs that were notable for their selectivity. The first of these salons, modeled on the annual exhibitions of the Linked Ring in London and the Photo Club of Paris, was held at the Pennsylvania Academy of Fine Arts under the sponsorship of the Photographic Society of Philadelphia and coincided with the birth of his daughter, Katherine (Kitty), in the autumn of 1898.

Stieglitz's ambitions as an artist and organizer are remarkably well symbolized in this picture. It was shown in 1902 at the National Arts Club in New York in an exhibition that coincided with Stieglitz's founding of the Photo-Secession and was published in January 1903 in the inaugural issue of the movement's journal, *Camera Work.* Stieglitz took every opportunity to place contradiction and duality at the center of his art and life, and this picture exemplifies his urge to reconcile opposites. The title establishes a poeticizing context that recalls the symbolism prevalent in art and literature of the time, yet it also alludes to photographs as the product of a machine and to the eternal dialogue between the handmade and the mechanical. Stieglitz believed that machines could be very beautiful objects and that a machine—the camera—could be a tool for the creation of art when guided by an artist.

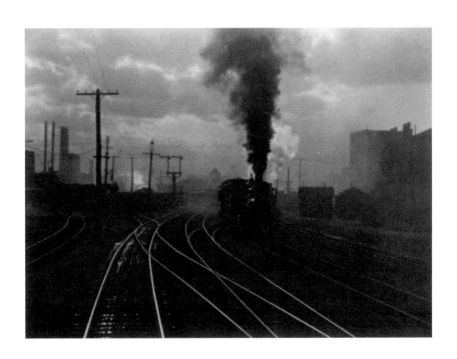

PLATE 5

Landscape, the Tyrol
1904

Platinum print
23.5 × 31.5 cm
84.XM.156.10

If one were to judge from the foregoing pages, it would appear that Stieglitz was chiefly a chronicler of cities he loved. Some of his best early work was inspired by the landscape, however. He had spent a lot of his spare time during his student years in Germany walking and photographing the land. His attention alternated between landscape and the figure, with a happy compromise often being the figure in a landscape (pl. 1). Sometimes the figures took the form of trees, which Stieglitz studied for their own character as though they were the subjects of a portrait. Trees became a dominant subject in his later work (pl. 45).

During the summer of 1904 Stieglitz traveled around Europe with his wife and daughter, making stops in Berlin, Dresden, Munich, and London. In Dresden he visited the photography exhibition at the Grosse Künstaustellung, where he saw large-scale landscape photographs by Hugo Henneberg, Heinrich Kuehn, and Hans Watzek. These left such a strong impression on him that in the spring of 1906 he arranged for an exhibition of their very painterly gum bichromate prints at The Little Galleries of the Photo-Secession (later 291).

Stieglitz's own Tyrolean landscape reflects the strong impression that the work of his German and Austrian counterparts had on him. It is also a critique, because the painterly quality is achieved without imitating painting. "The artist is compelled to deal both with nature and his material in order to create something new that is neither nature in the ordinary sense nor mere material. Nature and art—art and photography! There are very few . . . who understand the connection existing between these terms," Stieglitz wrote of Henneberg, Kuehn, and Watzek in the January 1906 issue of *Camera Work*.

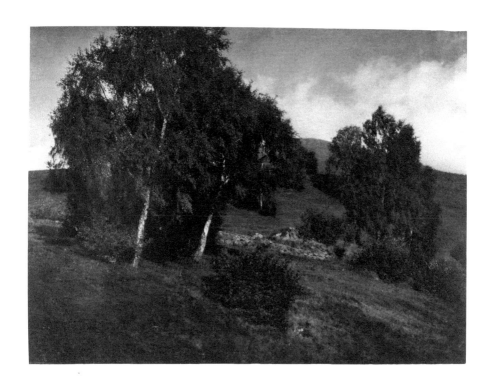

PLATE 6

The Steerage

1915 photogravure
from a 1907 negative
32.1 × 25.7 cm
84.XM.695.19

Twenty-five years or so after snapping the shutter, Stieglitz described the circumstances of this extraordinary image as follows: "Coming to the end of the [first-class] deck I stood alone, looking down. There were men, women and children on the lower level of the steerage. A narrow stairway led up to a small deck at the extreme bow of the steamer. A young man in a straw hat, the shape of which was round, gazed over the rail, watching a group beneath him. To the left was an inclining funnel. A gangway bridge, glistening with fresh white paint, led to the upper deck.

"The scene fascinated me: A round straw hat; the funnel leaning left, the stairway leaning right; the white drawbridge, its railings made of chain; white suspenders crossed on the back of a man below; circular iron machinery; a mast that cut into the sky, completing a triangle. I stood spell-bound for a while. I saw shapes related to one another—a picture of shapes, and underlying it, a new vision that held me: simple people; the feeling of ship, ocean, sky; a sense of release that I was away from the mob called the 'rich.' Rembrandt came into my mind and I wondered would he have felt as I did." Stieglitz tells how he raced back to his cabin to fetch his camera, which was loaded with one unexposed plate. "Could I catch what I saw and felt?"

Ironically, Stieglitz apparently did not immediately recognize the importance of *The Steerage* until three or four years after he exposed the negative, since there are no surviving platinum or gelatin silver prints contemporaneous with the exposure. Today we admire this picture for the remarkable unity of humanist and formalist values; it is a tightly crafted composition and a powerful social document.

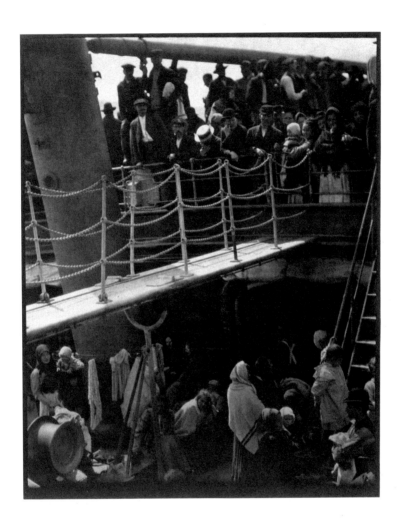

By 1907, the year Stieglitz made the self-portrait that illustrates the introduction to this book (p. 7) and the negative for *The Steerage* (pl. 6), he had become a legend in New York, being sought out for advice by collectors, photographers, and artists. He spent the summer of 1907 in Europe with Kitty (pls. 7–8) and Emmeline (pl. 9). They arrived in Paris shortly after the momentous announcement that Auguste and Louis Lumière had perfected the autochrome process, and Stieglitz immediately began to experiment with color, using his family as his first models. The autochromes of Kitty were the continuation of an extended series of studies of her that were first exhibited in London in 1900 under the title *Photographic Journal of a Baby.*

The luscious color in Lumière plates was based on individual grains of starch dyed green, red, and blue (the primary colors of light) coated in thick layers onto a glass plate. The top layer of panchromatic gelatin silver emulsion acted as the recording medium for what the minute color filters let through for the eye to see.

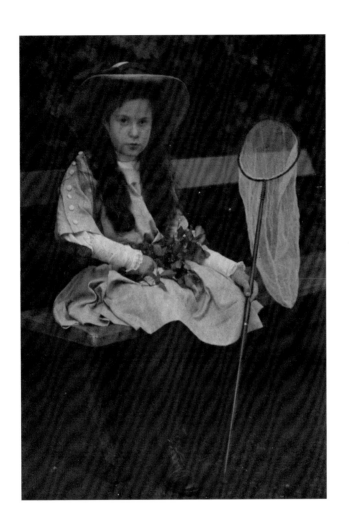

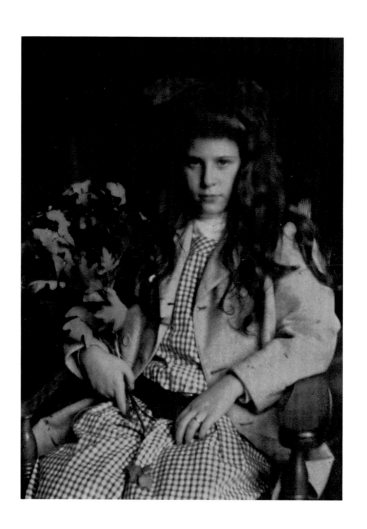

PLATE 10

Konrad Cramer

1912–14

Gelatin silver bromide print
24.2 × 19.3 cm
86.XM.622.7

Between the first publication of *The Steerage* (pl. 6) in 1911 and the end of World War I, Stieglitz withdrew into a more private phase in his own photography and concentrated on portraiture. He also began to question the underpinnings of the medium and to divert his attention to the work of painters and sculptors, some of whom became his chief subjects in a series of portraits.

Konrad Cramer, a recent art school graduate, immigrated to New York in 1911 with Florence Ballin, his young American bride whom he had met in Germany. They brought with them firsthand experience with key experimental artists of the German Blue Rider movement, in particular Wassily Kandinsky, Alfred Kubin, Franz Marc, and Gabriele Münter. The Cramers soon learned about *Camera Work* and read Gertrude Stein's article on Matisse and Picasso, published there in August 1912. It may have been through Cramer that Stieglitz was introduced to Kandinsky's *Concerning the Spiritual in Art*, from which he printed

excerpts in *Camera Work* in July 1912. Stieglitz was greatly impressed by Kandinsky's belief that art should express "emotional, temperamental, subjective states" and purchased one of his paintings from the Armory Show in 1913.

Cramer, one of the first artists in America to paint a completely abstract picture, represented an attitude that Stieglitz had begun to think of as "antiphotographic." Cramer's painting style showed the influence of Cubist and Expressionist art, but he gave up his attachment to recognizable subjects reluctantly. Stieglitz's portrait of him expresses the young man's energy and forward-reaching attitude. Stieglitz did not, however, choose to exhibit Cramer's work at 291.

Cramer turned to photography himself about 1935, when Stieglitz was at the end of his career, and worked almost exclusively in this medium for the remainder of his creative life.

PLATE II

Marsden Hartley

Circa 1915

Platinum print
25.2 × 20 cm
93.XM.25.61

Marsden Hartley was introduced to Stieglitz
by the Irish-American poet Shaemas
O'Sheel. They first visited 291 in the spring
of 1909, during Edward Steichen's exhibi-
tion there. Hartley's recollection of his first
visit illuminates the ambiance of the gallery:
"There was . . . a Parisian tone pervading
this place. We began to hear names like
Matisse, Picasso, Cézanne, Rousseau . . .
and it was from all this fresh influx that
I personally was to receive new ideas and
new education. There was life in all these
new things, there was excitement, there
were healthy revolt, investigation, discovery,
and an utterly new world opened out of
it all. A new enchantment and satisfaction
was to come." Two weeks after their first
meeting, Hartley found himself included
in the landmark *Younger American Painters*

exhibition at 291 along with Arthur B. Carles,
Arthur Dove, John Marin, Alfred Maurer,
and Max Weber. Hartley's still-life arrange-
ments in this exhibition showed the influ-
ence of Picasso and Cézanne.

This portrait is greatly out of character
with Stieglitz's earlier style in its violation
of several rules of good portraiture. The
picture frame divides the head from the
shoulders; the single light source casts deep
shadows, including a scarlike one across
the cheek; and the eyes glow with unnatural
reflections. It is as though Stieglitz was
in sympathy with Hartley's desire to expand
the limits of traditional painting.

PLATE 12

The Picasso-Braque-African Carving Exhibition at 291
1915

Platinum print
19.6 x 24.7 cm
86.XM.622.2

Stieglitz established his reputation outside the field of photography by bringing the work of Rodin, Toulouse-Lautrec, Cézanne, and Picasso to New York for the first time (Picasso was given his first solo exhibition anywhere at 291 in 1911). During the last five years of the gallery just three photographers were shown: Baron de Meyer (late 1911), Stieglitz (early 1913), and Paul Strand (early 1916). The balance of the exhibitions presented paintings, prints, drawings, and sculpture.

Stieglitz began to express himself through the installations at 291, such as the one shown here that juxtaposes a Picasso drawing, a carving from equatorial Africa, and a wasp's nest (the frame of a Braque drawing can be seen at the right edge). His delight in the comparison of opposites is plain, and in his photograph of a part of the exhibition he skillfully allocates for each component of his still-life composition a position of equal importance. Through his photograph Stieglitz asserts that the forces of nature and the products of the human hand can exist as a universe of equals. Such installations were so important to Stieglitz that he carefully photographed each one, creating a body of work that is about the process of art itself. "It is this antiphotography . . . that I am using in order to emphasize the meaning of photography," Stieglitz wrote to a friend in 1912, attempting to explain his convictions. The concept of "antiphotography" became a recurrent theme in his art and writing.

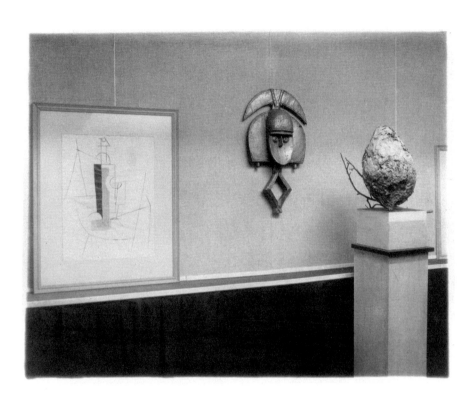

PLATE 13

Alfred Maurer

1915

Gelatin silver print
23.7 x 18.9 cm
93.XM.25.60

Alfred Maurer entered Stieglitz's circle
about 1909 and was one of the first individ-
uals to direct Stieglitz's attention away from
photography. Between 1897 and 1914 the
painter lived and worked in Paris, where
he came under the influence of Matisse, and
thus may be credited, along with Edward
Steichen, for Stieglitz's introduction to
Matisse's art.

 Here, Maurer looks as though he
is about to engage Stieglitz in conversation.
Stieglitz typically photographed artists
at his gallery when they came to visit while
their work was on display. Maurer, how-
ever, is not recorded as having had an exhi-
bition with Stieglitz after 1910, although
one was planned for 1917–18. The authorship
of this painting has not been established
for certain, but it may be a work by Maurer
that was brought from storage and hung
temporarily.

PLATE 14

Sherwood Anderson

1923

Platinum print
24.4 × 19.3 cm
87.XM.94.5

Sherwood Anderson, a novelist, poet, and author of short stories and essays, is perhaps best known for his book *Winesburg, Ohio* (1919). He once described Stieglitz as a "city plowman," and compared him with his fictional Uncle Jim Ballard, a farmer who had tilled the same fields for fifty years and was totally absorbed by his milieu. "And so Stieglitz is to me," Anderson wrote. "He in the city releasing the men about him, turning the imaginations of other men loose in his city. I get him so, as I get Uncle Jim . . . his workroom and the city, the fields he plows, he giving me thus also the city, as Uncle Jim the fields. . . . Himself asserting, sometimes preaching. His preachings and his assertions haven't mattered half as much to me as his devotion."

Anderson is positioned before a painting by Georgia O'Keeffe, whose work he greatly admired. It was on display at the Anderson Galleries in 1923. The writer, with his topcoat and scarf still in place, is depicted as though he has just walked into the room. His deeply melancholic expression suggests that he was not uplifted by the process of being photographed.

PLATE 15

**From the Back
Window of 291**

April 1915

Platinum print
24.6 × 19.5 cm
84.XM.1038.6

When Stieglitz began to concentrate on his
own creative life again in about 1915, after
a decade spent promoting the idea of pho-
tography as fine art through exhibitions at
291 and in the pages of *Camera Work,*
one of his first experiments was a series of
photographs made out the back window
of the gallery at various times in different
seasons. One of his subjects—a small tree
growing in the backyard—is here seen after
a snowstorm that has caused a dendritic
pattern of light and dark. Stieglitz has
seized upon nature's own deep tonal con-
trast. His objective is directly opposite that
of *Landscape, the Tyrol* (pl. 5) of a decade
earlier and a reversal of his 1906 hypothesis
that "the aim of the artist is to recreate
the impression which the aspect of nature

produced upon him. This requires the
well-considered suppression of details and
the toning down of hard and sharp lines.
. . . It is by this mental process that the artist
evolves out of nature an art which still is
of nature."

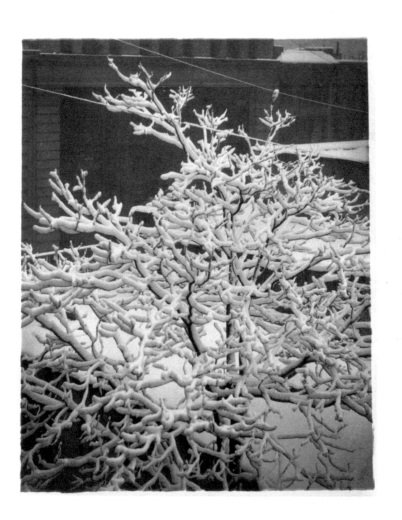

PLATE 16

Ellen Koeniger

1916

Gelatin silver print
11.1 × 9 cm
93.XM.25.4

"Strange as it may sound, my photographic experimenting had to be side-tracked for years, for the bigger work I was doing in fighting for an idea," Stieglitz wrote in July 1915. Between January 1915, when he celebrated his fifty-first birthday, and the summer of 1916 Stieglitz worked persistently to find new directions for his art. He abandoned his Pictorialist origins and eschewed handwork on the print or negative. "Just the straight goods," he declared.

In the summer of 1916 Stieglitz made a breakthrough series of photographs of Ellen Koeniger in a revealing wet bathing suit (pl. 16 and p. 121). She was the niece of Frank Eugene, an American artist and photographer living in Germany. The sharply focused negatives were exposed in bright sunlight and realized in crisp gelatin silver prints. About the same time, Stieglitz remarked: "Machines have great souls.— I know it.—Have always known it.—But they must be given a chance to show them." For reasons that may have to do with the advent of Sigmund Freud's writings, Stieglitz began to equate "soul" with "libido" and to express his longings in photographs of young women whom he encountered in their moments of relaxation as visitors to Oaklawn, the Stieglitz family estate at Lake George, New York.

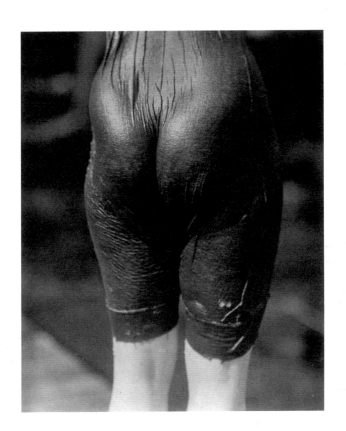

PLATE 17

Marie Rapp

1916

Platinum print
24.4 × 19.3 cm
84.XM.217.9

Stieglitz prided himself on never making portraits for hire—his subjects were almost exclusively his family and friends—although he complained about doing one commissioned portrait in 1922. This picture is of Marie Rapp (later Boursault; see pl. 32), who went to work for Stieglitz in 1911 at the age of eighteen as his part-time secretary at 291. She became Stieglitz's closest confidante for the half decade preceding his separation from Emmeline (whom he rarely photographed) and the beginning of his alliance with Georgia O'Keeffe in 1917.

Dressed for winter in a fashionable fur-collared coat, Rapp keeps her hands snuggled in a fur muff that is almost hidden in shadow. Her expression is remarkable for its profound serenity. More than any other photograph, this portrait, a study in reciprocal adoration, is a key precursor to the O'Keeffe series, which commenced a few months after this picture was made. As in the O'Keeffe portraits, Stieglitz has ignored here the stern and impersonal dogma of Modernism, allowing himself to be consumed by the emotion of the moment unfolding before him. We see here the triumph of his belief that the objective must serve the subjective and, in art, feeling should dominate design.

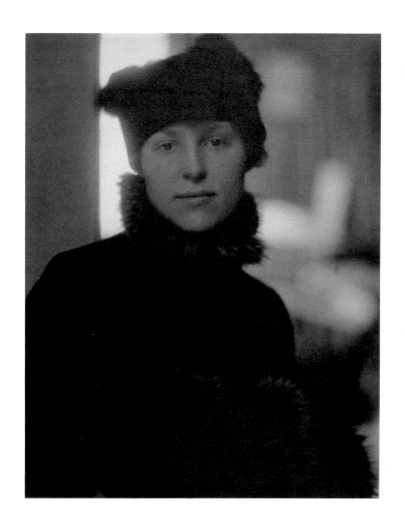

PLATE 18

Dorothy True

1919

Gelatin silver print
24 × 19.2 cm
91.XM.63.1

The art term *Modernism* eludes precise definition. Most scholars of the subject would agree, however, that experimentation and the risk of failure are central to its essence. The evidence of experimentation of the type seen in the work of László Moholy-Nagy, Man Ray, and Alexander Rodchenko from the 1920s is mostly absent in Stieglitz's work of the same period. His experiments dealt more with the process of perception and the element of human psychology, using the methods of straight photography, as exemplified in the portrait of Marie Rapp (pl. 17). Occasionally he made a work that deviated from conventional materials and procedures, such as this study of O'Keeffe's friend Dorothy True. It was achieved by the amalgamation of two exposures, one representing her face printed very lightly, the other, her leg. Stieglitz did not systematically pursue the idea of composite imagery, and the possibility remains that this charismatic picture is the result of a deliciously accidental double exposure.

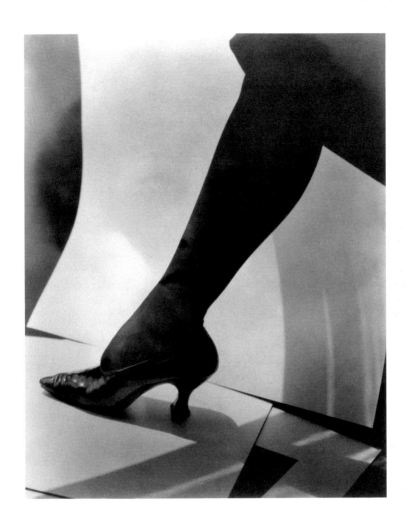

PLATE 19

Margaret Treadwell

1921

Palladium print
25.2 × 20.1 cm
87.XM.94.3

This rich and moody print is an example
of the black palladium process Stieglitz
was experimenting with between 1919 and
1921. He wrote in August 1921: "It fright-
ens me to see how much material I use
to get a print or two that finally seems to be
something alive and smiling at me a sort
of: 'Not so bad'—Georgia & I counted up the
number of prints I might call 'additions'—
made since up here . . . about 14."

Between 1920 and 1922 Stieglitz be-
came quite frustrated with the reduced
quality of photographic materials. He had
to experiment constantly to maintain his
high standards. In 1922 he wrote: "Today is
another Palladio day—My hands look a
sight—water at 40—hard water at that—acid
developer—& my hands all day virtually
in the soups."

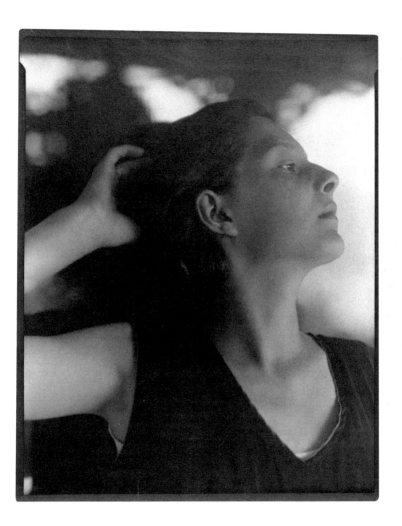

PLATE 20

Georgia O'Keeffe:
A Portrait

1917

Platinum print
24.4 × 19.5 cm
91.XM.63.3

During the first half of 1916, when Georgia O'Keeffe was living in New York, she was included in a group exhibition at 291. Legend has it that toward the end of the exhibition she visited the gallery to see her art hung for the first time, appearing "thin, in a simple black dress with a little white collar." "She had a sort of Mona Lisa smile," Stieglitz recalled, and reportedly demanded that he remove her works from the walls because he had not asked her permission to display them.

In mid-1917 O'Keeffe, by then living in Texas, returned to New York to see her first solo show, also at 291. She soon became Stieglitz's muse and principal subject, leading him into the most productive decade of his life. Stieglitz wrote to a friend in June 1918: "She is much more extraordinary than even I had believed— In fact I don't believe there ever has been anything like her—Mind and feeling very clear—spontaneous—& uncannily beautiful—absolutely living every pulse beat."

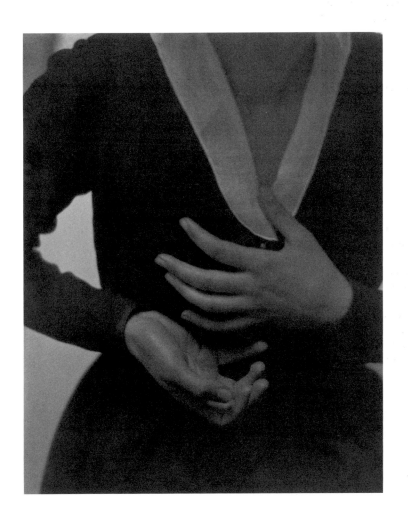

PLATE 21

Georgia O'Keeffe:
A Portrait

1918

Gelatin silver print
24.2 × 19.7 cm
93.XM.25.32

Stieglitz wrote in September 1917 that "nothing has moved me sufficiently to want to photograph or do much of anything—I have tried several attempts to get something of the daughter [Kitty]—a few interesting plates but none quite satisfactory." This statement perhaps reflects his unhappiness at being separated from O'Keeffe, who, after her short visit to New York in 1917, had returned to Texas. "I want her to live—I never wanted anything as much as that. She is the spirit of '291'—not I," Stieglitz wrote in the spring of 1918. O'Keeffe's arrival in New York in June 1918 prompted Stieglitz to separate from Emmeline, his wife of twenty-five years, to live with O'Keeffe. By his own account, one day in early July 1918, while Emmeline was shopping, he packed his personal belongings in an hour and a half and moved them from the apartment they shared at 1111 Madison Avenue to the studio of his niece Elizabeth at 114 East Fifty-ninth Street. At summer's end Stieglitz proposed financing a year's residence in New York for O'Keeffe, during which she would have no responsibilities other than to paint. She accepted and ended up staying permanently, showing the results of five years' effort at an exhibition held in early 1923.

While Stieglitz had created many stunning individual portraits, his preferred approach for his most treasured family and friends was the serial portrait. O'Keeffe became the subject of his most extended series of pictures of a single individual. He photographed her from 1917 through the mid-1930s, often focusing on her hands. The corpus was given the name *Georgia O'Keeffe: A Portrait.*

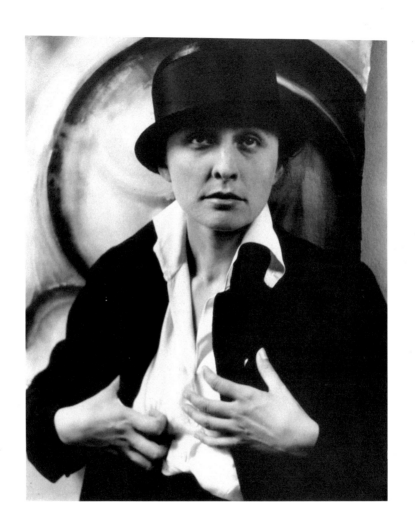

PLATE 22

Georgia O'Keeffe:
A Portrait

1918

Palladium print
24.3 × 19.3 cm
93.XM.25.53

The fifth-floor studio that O'Keeffe and
Stieglitz shared gathered light and, in the
summertime, heat via its skylights. The
summer of 1918 in New York was one of the
hottest in memory. "It was so hot that I usu-
ally sat around painting with nothing on,"
recalled O'Keeffe, whose various states
of undress were seized upon by Stieglitz as
an opportunity to photograph her.

For comfort O'Keeffe often wore a
diaphanous white kimono with an embroi-
dered floral pattern. Here her uncoiffed hair
flows over her shoulders in a composition
that effectively crosses back and forth
between the real and the ideal, the declared
and the symbolic, the self-evident and the
hidden. O'Keeffe gazes directly at the pho-
tographer, thus involving the viewer in the
experience. She recalls not only generic

Madonna figures of the *Virgo Lactans* type
in Christian iconography but also oriental
goddesses whose hands cup their breasts.
Stieglitz no doubt intended the general
association of sexuality as an expression
of the sacred.

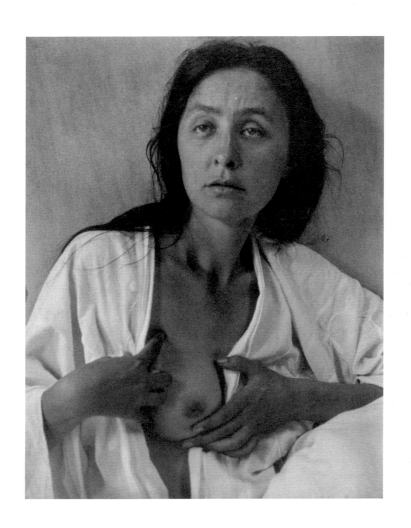

PLATE 23

Georgia O'Keeffe:
A Portrait
1918

Palladium print
24.3 × 19.3 cm
93.XM.25.42

About a month after Stieglitz's separation
from Emmeline, his mother, Hedwig, in a
surprise move, invited O'Keeffe to join the
family sojourn at Oaklawn, where there
were plentiful opportunities to photograph
outdoors but little privacy. "It seems as
if O. had always been here—Everyone likes
her & she seems happy," wrote Stieglitz,
contrasting O'Keeffe with Emmeline, who
he perceived was not comfortable there.

We can imagine Oaklawn as being in
some ways like the Bentley Farm in
Sherwood Anderson's *Winesburg, Ohio,* a
book read by both Stieglitz and O'Keeffe
when it was published in 1919. "At meal
times the place was like a beehive," writes
Anderson. "At one moment all was quiet,
then doors began to open . . . and people
appeared from a dozen obscure corners."

Stieglitz and O'Keeffe returned to Oak-
lawn for a second visit in September. The
fall and winter of 1918 were the coldest in
many years. Here we see O'Keeffe dressed
for this weather. She strikes a self-protective
pose that seems to reflect the vulnerability
she may have been experiencing as a result
of the many changes in her life.

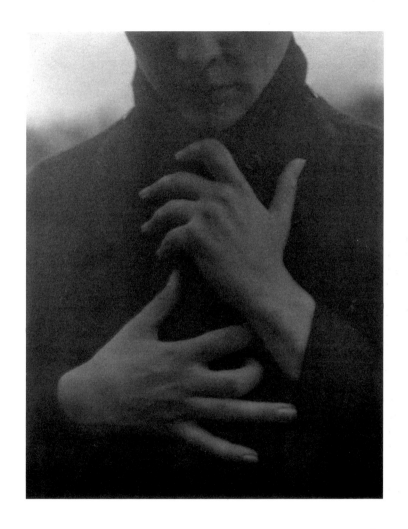

PLATE 24

Georgia O'Keeffe:
A Portrait
1919

Gelatin silver print
24.2 × 19.4 cm
93.XM.25.43

"My hands had always been admired since I was a little girl—but I never thought much about it," recalled O'Keeffe in 1977. "I was asked to move my hands in many different directions." This description is a clue to how actively Stieglitz directed his model, thus shaping what we see. Stieglitz wrote in early 1919: "Georgia is very wonderful— & has grown in every respect—Everyone remarks it—all those who have known her & know her—Her sister—Dorothy True."

O'Keeffe's hands are posed here with her *Drawing No. 17* of 1919 as a backdrop. Her thumb and index finger are about to squeeze one of the suggestive shapes. In 1974 she wrote three words—"No comments, please"—that were printed opposite a repro-duction of the charcoal drawing. This text leaves no doubt that Stieglitz's photograph was emblematic of the libidinous games they were engaged in at the time.

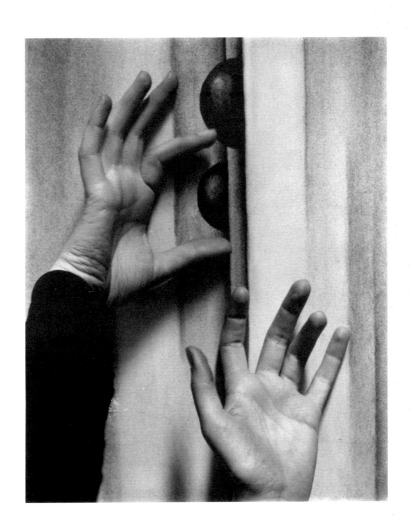

PLATE 25

Georgia O'Keeffe:
A Portrait

1923

Palladium print
18.2 × 18.5 cm
93.XM.25.66

Between 1921 and 1924 Stieglitz organized three exhibitions of his own photographs for the Anderson Galleries, each focusing on a different aspect of his work. In 1921 he selected a retrospective survey of pictures ranging in date from 1886 to 1921, including forty-five from the set that he had designated collectively as *Georgia O'Keeffe: A Portrait*. It was on this occasion that Stieglitz first showed publicly the core of the monumental series that he had been working on persistently over the four years that had elapsed since he initially photographed O'Keeffe in 1917 (pl. 20).

Not long before Stieglitz made this study of O'Keeffe standing in front of works by Paul Strand, she had written an essay on what photography meant to her. "I feel that some of the photography being done in America today is more living, more vital, than the painting and I know that there are other painters who agree with me," she wrote. "Compared to the painter the photographer has no established traditions to live on. . . . He must gain all the respect he is to have by what he himself can actually do."

Strand and O'Keeffe shared a period of infatuation with each other in 1917, but he soon married Rebecca Salisbury, whose face is seen to the left behind O'Keeffe's hat. Beginning in 1921, Stieglitz flirted continually with Rebecca, writing to her sometimes twice a day. This picture thus represents a double portrait of affection bestowed.

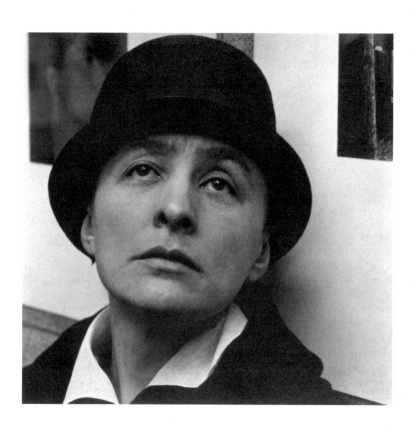

PLATE 26

Georgia O'Keeffe:
A Portrait

1918

Palladium print
24.1 × 19.2 cm
87.XM.94.1

The first American edition of Sigmund Freud's *Totem and Taboo* was published in New York in 1918. Stieglitz shared his copy with O'Keeffe, and it was still in her library when she died. Freud writes in a voice that could be Stieglitz and O'Keeffe in dialogue: "For us the meaning of taboo branches off into two opposite directions. On the one hand it means to us sacred, consecrated: but on the other hand it means uncanny, dangerous, forbidden, and unclean."

In 1917 O'Keeffe created a highly suggestive small phallic sculpture modeled in plasticine. By 1918 it had become a totemic symbol of her union with Stieglitz. Their collaboration, with its daring exploration of the taboo forbidding public demonstrations of sexuality and its references to primitive rites of magic and fertility, was revolutionary for the time.

Stieglitz also owned a copy of Carl Jung's *Psychology of the Unconscious* (1916), where Jung writes, in the context of the symbolism of "the mother and rebirth," that "the whole art of life shrinks to the one problem of how the libido may be freed in the most harmless way possible."

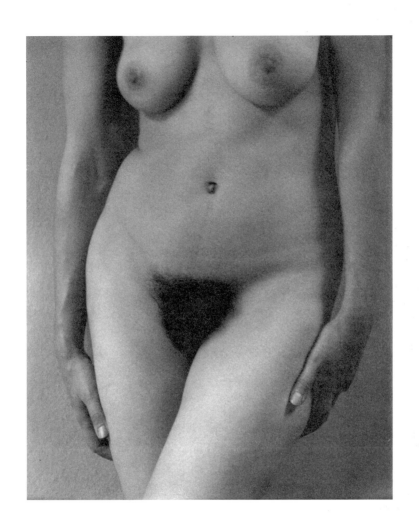

PLATE 27

**Georgia O'Keeffe:
A Portrait**

1921

Gelatin silver print
10.3 × 8.2 cm
93.XM.25.44

PLATE 28

**Georgia O'Keeffe:
A Portrait**

1924

Gelatin silver print
9.2 × 11.8 cm
93.XM.25.71

PLATE 29

**Georgia O'Keeffe:
A Portrait**

1929

Gelatin silver print
10.1 × 3.7 cm
93.XM.25.21

These pictures of O'Keeffe recall the wet swimsuit series for which Ellen Koeniger was the model (pl. 16 and p. 121). The veiled eroticism of the Koeniger studies is replaced by the image of a health-conscious woman in communion with nature. Stieglitz expressed himself in July 1923 about how O'Keeffe's lean body affected him: "When I look at her I feel like a criminal.—I with my rickety old carcass & my spirit being tried beyond words.—There is something in me just lacking. . . . I suppose my physique has never been equal to the demands I made upon it."

Most of the photographs reproduced in this book were created with a tripod-mounted view camera, a sizable piece of equipment designed to expose eight-by-ten-inch negatives. Stieglitz also used a hand-held Graflex, whose manufacturer used the slogan: "You can't miss it with a Graflex. The ideal outfit for high speed work." No dark cloth for focusing was required, and Stieglitz saw the full-size picture right side up—not inverted top to bottom as with the eight-by-ten-inch camera—at the instant of exposure. Using this apparatus, he photographed O'Keeffe and others in more casual situations than formal portraiture called for, and he sometimes trimmed these prints to show much less than the full negative. Stieglitz called this part of his work "no account," but noted to a friend, "they take time in spite of their no-accountness."

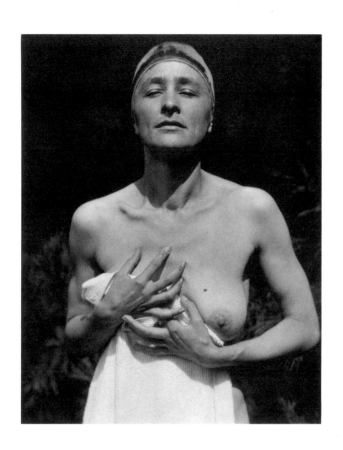

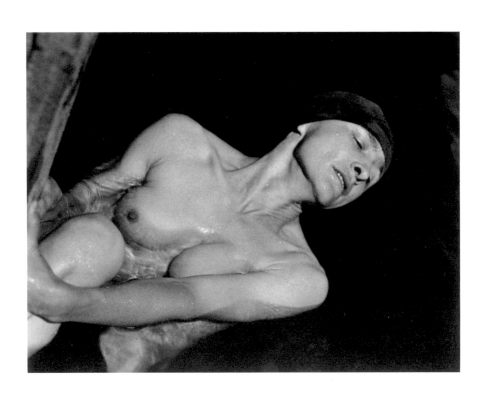

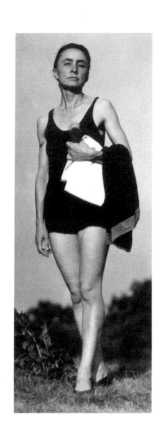

PLATE 30

Apple Blossoms

1922

Gelatin silver print
9.3 × 11.2 cm
93.XM.25.30

Stieglitz was a man of many contradictions,
which he expressed in both words and
actions. In 1922, for example, he acknowl-
edged his mother's increasingly fragile
health by turning his back on her physical
and emotional needs, according to reports
by his family. Since Stieglitz was the eldest
of six children, he occupied a special posi-
tion in her eyes, and much was expected of
him. During the summer of 1922, while
withholding sympathy for his dying mother,
he offered a bouquet of flowers to O'Keeffe
through this picture. By referring to her
as a "little girl," he manifests a viewpoint
often seen in his portraits of her as a
childlike figure in need of his protection.

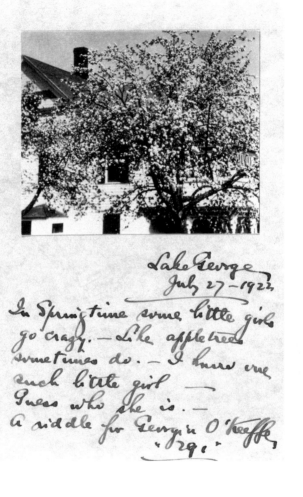

Lake George
July 27 - 1922

In Springtime some little girls
go crazy. — Like appletrees
sometimes do. — I know one
such little girl —
Guess who she is. —
a riddle for Georgia O'Keeffe
" 29 "

PLATE 31

Spiritual America

1923

Gelatin silver print
11.5 × 9.1 cm
93.XM.25.12

According to Sue Davidson Lowe, Stieglitz's grand-niece, his siblings granted him exclusive use of an outbuilding that had been the potting shed of a former greenhouse at the Lake George property. In it he created the first space he had ever had that was dedicated exclusively to developing and printing his negatives. The existence of this facility may have created a reason for Stieglitz to increase the volume and intensity of his work, and he began to explore subjects around the property that held strong meaning for him, such as its buildings, trees, and animals. Here he concentrates on the anatomy of a horse that his father had acquired more than thirty-five years before.

Stieglitz was searching for symbols that expressed the past, present, and future. Although he had not yet come to apply the word *equivalent* to pictures that were intended to stand for a broad range of intellectual and emotional experience, one critic saw in *Spiritual America* the equivalent of a written philosophy, thus establishing a correlative experience.

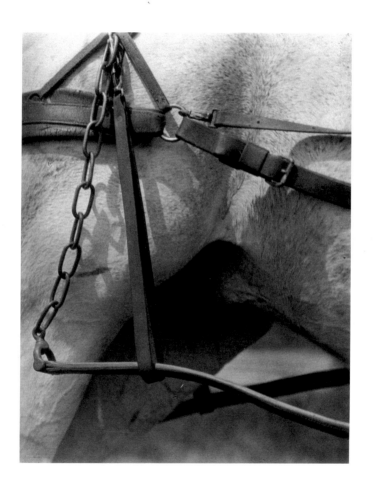

PLATE 32

George and Yvonne Boursault, Lake George

1923

Gelatin silver print
11.5 × 8.8 cm
86.XM.622.3

After their mother's death in the fall of 1922, the children of Edward and Hedwig Stieglitz, who had jointly inherited the Lake George property, began to talk of selling it (the grand residence, Oaklawn, had been sold in 1919). Stieglitz and O'Keeffe, who occupied a renovated farmhouse on a hill behind the main house, were nevertheless put in charge of planning the use of the estate during the summers of 1923 and 1924. They took this opportunity to invite a constant stream of their New York friends to visit, among them George and Marie Boursault and their two-year-old daughter Yvonne. Marie Rapp (pl. 17) had been introduced to George Boursault by Stieglitz, for whom she had worked at 291 for a dozen years. Boursault, shown here at Lake George with Yvonne, was the son of one of Stieglitz's friends at the Camera Club of twenty years earlier.

Yvonne was the first youngster with whom Stieglitz had had much contact since the childhood of his own daughter, Kitty (pls. 7–8). During the summer of 1923 he made nearly fifty studies of Yvonne, including this snapshot. It incorporates more elements of accident and chance—shadows, the clothesline, and divergent glances—than Stieglitz typically admitted into his work. This series may be compared to the multipart portrait of Kitty that he had begun about 1898.

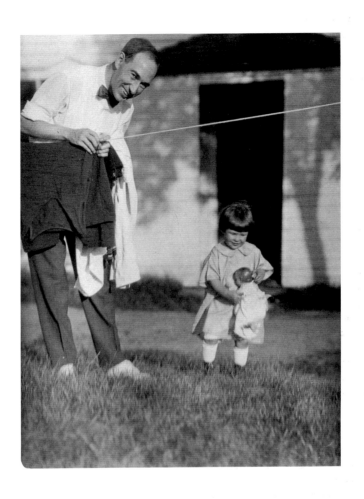

PLATE 33

Georgia and
Ida O'Keeffe,
Lake George
1924

Gelatin silver print
11.1 × 8.9 cm
94.XM.25

The summers of 1923 and 1924 at Lake George were full of visitors, which gave Stieglitz cause to do more double and group portraits than usual. Among the guests was Ida Ten Eyck O'Keeffe, Georgia's younger sister, who was an amateur painter and licensed nurse. In this picture of the two, Stieglitz harnesses the effects of glance and expression to present a psychological study of their characters.

Deep shadows from bright sunlight establish a somewhat sinister mood. O'Keeffe gazes reproachfully at Stieglitz through the lens of his reflex camera, which he is holding at waist level aimed upward, while Ida casts a nervous glance her sister's way as if to suggest that she knows something that her sister doesn't. Stieglitz's divorce from Emmeline had been finalized about the time this picture was made, and he and O'Keeffe were contemplating their own marriage, which was formalized in December 1924.

PLATE 34

Emile Zoler,
Georgia O'Keeffe,
and Paul Rosenfeld,
Lake George
Circa 1924

Gelatin silver print
7.6 × 11.4 cm
93.XM.25.33

Stieglitz worked best with a composite por-
trait in many parts or in one-on-one portrait
sessions, which may be why he did not
make very many double or group pictures.
The summers of 1923 and 1924, however,
invited a more casual approach to memori-
alizing friends' visits to Lake George.

Emile Zoler, at left, was a painter
whose work did not have much of an audi-
ence, but he became Stieglitz's devoted
acolyte and volunteer assistant at 291 after
they were introduced by Marsden Hartley
(pl. 11) about 1909. Tanned and handsome,
he sits next to O'Keeffe, who gazes slyly at
the lens. Paul Rosenfeld, at right, was
possibly Stieglitz's closest confidant at this
time. Stieglitz wrote long and expressive
letters to him detailing the successes and
failures of various photographic experiments.

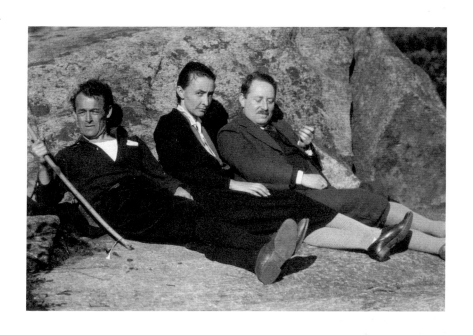

PLATE 35

Music: A Sequence of Ten Cloud Photographs, No. 1

1922

Gelatin silver print
18.8 × 24 cm
87.XM.94.4

The year 1922 was one of the most signifi-
cant in Stieglitz's emotional life. His daugh-
ter, now age twenty-three, was married in
June; a few months later, at about the time
his mother died, Stieglitz learned that he
would soon be a grandfather. Meanwhile,
during the summer, he and O'Keeffe consid-
ered the possibility of having a child of
their own, an idea of which he disapproved
because of his own perceived failures as
a father to Kitty and because he was appre-
hensive about the adverse effects maternity
might have on O'Keeffe's art.

It was a natural time for cosmic themes
to be addressed in his photographs. Stieglitz
decided in the middle of 1922 to focus his
attention on the world above his head, which
resulted in a series that he exhibited in 1923

as *Music: A Sequence of Ten Cloud Photo-
graphs* (he later called them *Clouds in
Ten Movements* and *Music: A Series of Ten
Pictures*). The combination of the stormy sky
and diminutive building establishes a tone
of anxiety and foreboding. The picture is
full of deep melancholy, reflecting Stieglitz's
emotional complexion at this time.

In the 1922 series of cloud studies the
horizon is always present, no doubt because
the negatives were made with an eight-by-
ten-inch camera on a tripod that could not
be rotated acutely upward to eliminate
the skyline. The majority of the later cloud
pictures were created on four-by-five-inch
negatives.

74

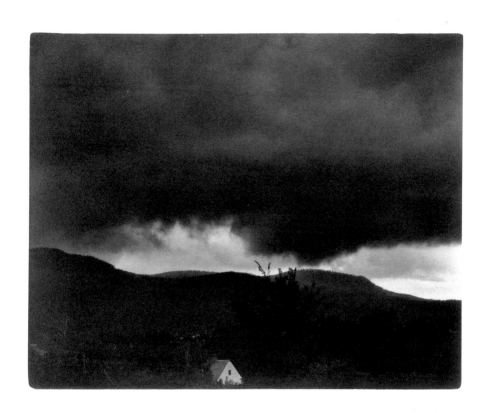

PLATE 36

Songs of the Sky, No. 2
1923

Gelatin silver print
9.3 × 11.9 cm
91.XM.63.12

Another reason why Stieglitz assigned him-
self the project of photographing clouds
was to disprove the assertion by one critic
that his success at portraiture was a result
of his powerful, hypnotic personality. He
succeeded in creating just ten cloud studies
worth exhibiting during the first season,
all of them on eight-by-ten-inch negatives.
"It was great excitement—daily for weeks,"
he wrote. "Every time I developed [a cloud
negative] I was so wrought up, always
believing I had nearly gotten what I was
after—but had failed." In 1923 he began using
a four-by-five-inch camera, which allowed
him to easily point the lens overhead and
to make many more exposures than he could
with his larger camera.

The initial impulse seems to have
been to create a body of photographs that
carried the emotional impact of music.
"I had told Miss O'Keeffe I wanted a series
of photographs which when seen by Ernest
Bloch (the great composer) he would
exclaim: Music! music! Man, why that is
music!" The *Equivalents,* as in 1925 he
began to call the new cloud studies, were
designed to spark the imagination, enabling
the viewer to read into them specific con-
tent. Sometime after 1925 he retitled *Songs
of the Sky, No. 2* as *Equivalent: Portrait
of Georgia, No. 3,* thus giving identity to
what was otherwise an abstract composition
of light and atmosphere.

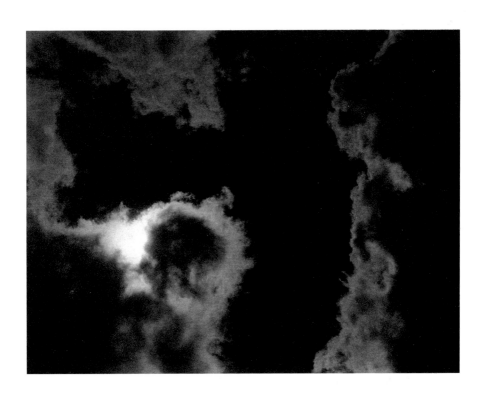

PLATE 37

Equivalent

1925

Gelatin silver print
11.9 × 9.2 cm
93.XM.25.80

The Museum of Fine Arts, Boston, acquired
twenty-seven Stieglitz photographs in 1924
at the urging of Ananda Coomaraswamy,
who saw in the cloud studies an affinity
with the meditative elements of Far Eastern
art. By the winter of 1924 Stieglitz had
achieved enough successes to support an
exhibition of sixty-one cloud pictures,
installed in one room at the Anderson Gal-
leries. He began to refer to these photo-
graphs as *Equivalents* in 1925 and saw them
as embodying the same spirit as abstract
painting and sculpture. The *Equivalents*
were also likened to the poetry of John Keats
and Samuel Coleridge, who grounded
their verses in natural phenomena filtered
through human feelings, and to music,

thought to be the purest form of abstract
expression. Stieglitz was not concerned with
displaying such images at their proper ori-
entation and would frequently mount them
sideways or upside down, thus transforming
raw nature into art.

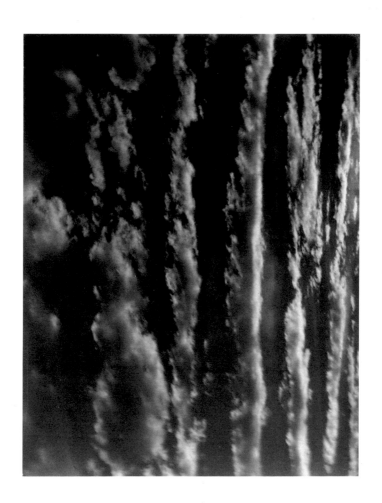

PLATE 38

Equivalent

1929

Gelatin silver print
11.9 × 9.2 cm
93.XM.25.13

Stieglitz believed that his *Equivalents* were the pure expression of his inner state of being. He rarely, if ever, explained in words what actual feelings or emotions were present when particular pictures were made, however. He expected that his audience would have an intuitive perception of their meaning that was parallel to the instinct that caused them to be created.

In Stieglitz's work biographical facts can illuminate individual images. This *Equivalent,* for example, suggests a sky that is choked with smoke and fire. Perhaps not so coincidentally, Stieglitz had begun to review his personal archives of letters, documents, and small publications and to give away, discard, and even burn those for which he had no further use. He spent the summer of 1929 in a smoldering rage over his life and the state of the world. There is no way of knowing for certain whether this picture was made during O'Keeffe's first absence from him, an extended period when she visited New Mexico and became involved with a dynamic and challenging new circle of friends, but it communicates a strong sense of apprehension.

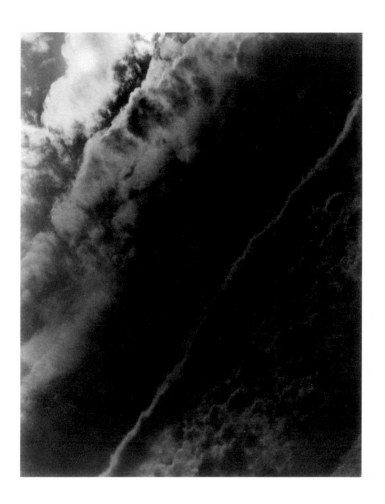

PLATE 39

Equivalent

1930

Gelatin silver print
12 × 9.1 cm
93.XM.25.9

In 1922 O'Keeffe wrote in one of her rare commentaries on photography that "nothing is less real than realism. . . . Details are confusing. It is only by selection, by elimination, by emphasis that we get the real meaning of things." Eight months later Stieglitz wrote that in photography "there is a reality—so subtle that it becomes more real than reality. That's what I'm trying to get down in photography."

If the preceding *Equivalents* reflect Stieglitz's attraction to a decontextualized tapestry of light and atmosphere, this image addresses how the photographer of clouds is always working with a subject that is totally outside of his control. The formation is full of soaring translucency and delicate energy that have been skillfully harnessed by Stieglitz.

There is no indication that Stieglitz knew the phrases "pencil of nature" or "photogenic drawing," which were coined by William Henry Fox Talbot in 1844, forty years before Stieglitz photographed his first clouds in Murren, Switzerland. However, the elegant marks and smudges that nature delivered to him at Lake George made possible sketches in light that were compared to John Marin's watercolors.

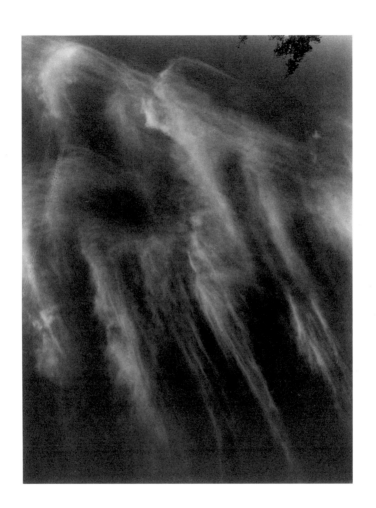

PLATE 40

Equivalent

1930

Gelatin silver print
9.2 × 11.8 cm
93.XM.25.14

In early 1931 Charlie Chaplin paid a visit
to An American Place, the gallery Stieglitz
had established in a small room on the
seventeenth floor of a building at 509
Madison Avenue. Georgia O'Keeffe's new
paintings, made during her first trip to
New Mexico in April 1929, were installed
at the time. Chaplin is reported to have
admired the paintings but spent consider-
able time looking at Stieglitz's photographs.
Herbert Seligmann was a bystander and
recounted the event: "Stieglitz told Chaplin
that the prints he had seen were really
only a prelude to an idea which he had had
in mind for twenty years: of a movie of a
woman's eyes, their changing expression,
the hands [pl. 20], feet, lips [pl. 25], breasts
[pl. 22], *mons veneris* [pl. 26], all parts of
a woman's body, showing the development
of a life, each episode alternated with
motion pictures of cloud forms on the same
theme, always re-sounding the main theme,
all without text, without actors, sprung from
life, as Stieglitz's photography had sprung."

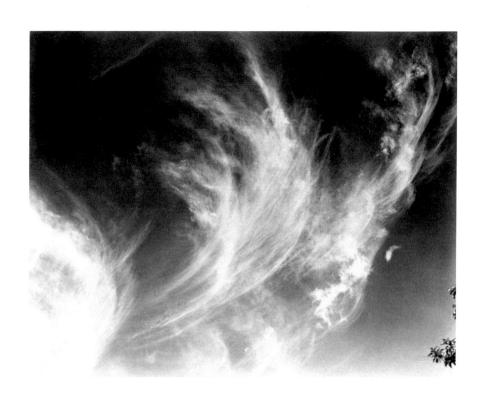

PLATE 41

From the Shelton
Looking North

1927

Gelatin silver print
11.5 × 8.9 cm
84.XM.914.1

Artists of every sort gain inspiration from
the places they inhabit. This is particularly
true for photographers, because their art is
usually dependent on what they can see.
After Stieglitz's brother Leopold decided to
sell the Manhattan property where Stieglitz
and O'Keeffe had been living, the couple
moved first into a studio and then, in the
fall of 1925, into dramatic new quarters—an
apartment in the Shelton Hotel on Lexington
Avenue between Forty-eighth and Forty-
ninth streets. It was from the thirtieth floor
of this location, which presented a view
looking north into the heart of midtown Man-
hattan, that Stieglitz began to survey the
skyline of the city from a perspective very
different from the street-level viewpoint
of his first New York series of thirty years
before (pl. 2).

Stieglitz had an ambivalent attitude
toward progress. The idea of the city as
a growing organism with buildings of ever-
increasing height was simultaneously

attractive and repellent to him. He admired
the human scale of the old neighborhoods
and was bitter that progress meant change,
but he could not escape the fact that he was
a prophet of the machine age and, there-
fore, an indirect contributor to the process.

This study incorporates elements of
old and new New York, a theme Stieglitz
had already addressed in a 1910 picture of
that very title, where a skyscraper under
construction is observed in the context of
the brownstones it is displacing. Here we
see three tall buildings lined up one behind
the other, each representing a different archi-
tectural idea. In the foreground is a struc-
ture whose steel skeleton has been overlaid
with Italianate arcades and a Mediterranean
tile roof. Behind it is an even taller tower
embellished with Gothic spires. In the far
distance is the metal framework of a par-
tially completed edifice, whose unclad form
anticipates functionalist principles.

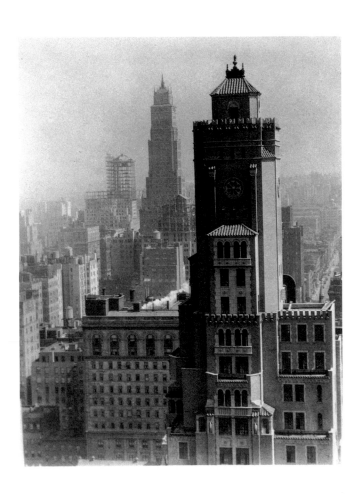

PLATE 42

From My Window
at the Shelton, North
1931

Gelatin silver print
24.3 × 19.1 cm
87.XM.62

Although Stieglitz and O'Keeffe moved into their new apartment in 1925, the earliest dated Shelton images are from 1927. They were first exhibited in 1931 at An American Place. Stieglitz's first Shelton experiments were exposed on four-by-five-inch negatives, no doubt because this format was quicker, easier, and cheaper to use for a subject that held uncertain potential for him. He soon discovered that the scale and tonal range of his subject were better served by a larger negative, as demonstrated here.

Between 1927 and 1932 the content of the Shelton series evolved from a concern with how camera and film model surface and mass in even tones of gray to a concern for the symbolism of light. The new content was verbalized by Dorothy Norman, a poet and volunteer at An American Place, whose book *Dualities* explored the reciprocality between light and dark. Stieglitz remarked to Norman in conversation: "Man is faced by inevitable choices. He is forever being asked . . . whether he believes in white or in black. But how is he to choose the one above the other? The very fact that the question is asked proves there is no absolute answer."

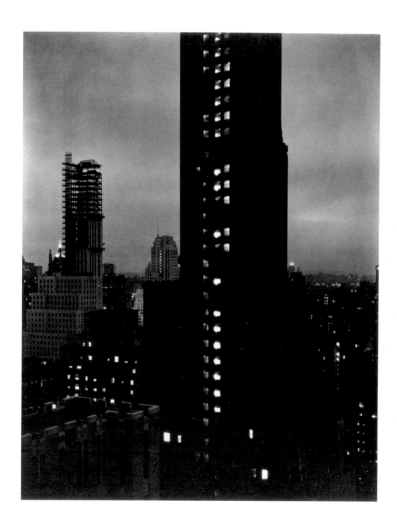

PLATE 43

From the Shelton

1931–32

Gelatin silver print
24.1 × 18.9 cm
93.XM.25.64

In the early 1930s Stieglitz brought the subject of dualities to the forefront of his thinking and experimented with ways in which this philosophical concept could be visualized. It was not the first time he had contemplated this issue, however. Both *Weary* and *The Terminal* (pls. 1–2), for example, pose the dichotomy of work and rest; *The Picasso-Braque-African Carving Exhibition at 291* (pl. 12) shows the dichotomy of man's and nature's way of sculpting; the 1918–19 O'Keeffe portraits often suggest the dichotomy of the Virgin and the vamp (pl. 22); and *Music: A Sequence of Ten Cloud Photographs, No. 1* (pl. 35) explores the dichotomy between earth and atmosphere.

Here several dualities are juxtaposed: black and white, solid and void, skeleton and epidermis, old and new. "There is with-in me ever an affirmation of light. Thus, no matter how much black there may be in the world, I experience tragedy, beauty, but never, futility. I am aware of the duality, the ambiguity of world forces forever at work. Yet it is when conflict hovers about a point, a focal point, and light is in the ascendancy, that I feel the necessity to photograph," Stieglitz remarked to Dorothy Norman about the time this photograph was made. "Each thing that arouses me is perhaps but a variation on the theme of how black and white maintain a living equilibrium."

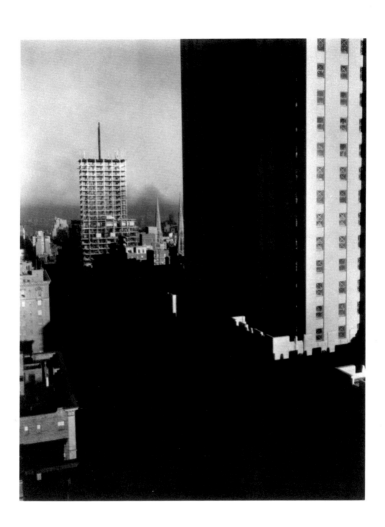

PLATE 44

Grasses, Lake George

1933

Gelatin silver print
18.8 × 23.7 cm
93.XM.25.63

In 1928 William Ivins, Curator of Prints at
the Metropolitan Museum of Art, agreed to
accept from businessman David Schulte
and other anonymous donors a gift of twenty-
three Stieglitz photographs. This was the
first time that photographs had been acquired
by the Metropolitan as works of art, an
achievement that had been one of Stieglitz's
lifelong objectives. Between the time of the
1928 gift and the making five years later
of this study of grasses, Stieglitz's personal
life took a number of surprising turns.

The biggest change was that O'Keeffe
had begun to spend increasing amounts of
time away from Stieglitz in places like Maine,
Bermuda, and Taos, New Mexico. The years
she had spent teaching school in Texas
about the time they first met inspired in her

a permanent love of the Southwest that
once again began to exercise its attraction
in the late 1920s. These journeys were
financed by income from the regular sale
of her paintings at top market prices. After
1911, Stieglitz, out of principle, never trav-
eled much beyond a radius of 150 miles
from New York and declined to accompany
his wife on her trips.

This study of a corner of a grassy
field at Lake George is an introspective and
meditative reverie. Stieglitz has observed
the refracted light of the dew-touched grasses
with tender sensitivity to nature's intimate
beauty. It shares with *Apple Blossoms*
(pl. 30) the ennoblement of a commonplace
actuality, and may reflect his melancholy
outlook at this time.

PLATE 45

Chestnut Tree,
Lake George
1932–34

Gelatin silver print
23.1 × 17.3 cm
84.XM.217.7

Stieglitz celebrated his seventieth birthday on January 1, 1934, which gave him reason to contemplate his own mortality. During 1933 he had returned to some of his earliest negatives (see pls. 1, 3–4), found stored at Lake George. For two or three years he concentrated on making new gelatin silver prints, using the negatives as agents to transport himself back several decades to vanished instants of his past. The new prints were included in his December 1934 exhibition at An American Place along with a series portrait of Dorothy Norman.

Dead trees on the family property at Lake George became a source of fascination for Stieglitz as early as 1923, when he wrote to a friend in London about his personal disintegration: "slow but sure: dying chestnut trees—all the chestnuts in the country have been dying for years: the pines doomed too—diseased: I, poor but at work: the world in a great mess." He began to photograph the dying chestnuts in earnest in 1932 and first exhibited them in 1934.

PLATE 46

Georgia O'Keeffe:
A Portrait
1930

Gelatin silver print
19.3 × 24.1 cm
93.XM.25.58

O'Keeffe was accompanied on her 1929 trip to New Mexico by Rebecca Strand. The two women spent the summer in Taos, where they resided in a cottage on the property of Mabel Dodge Luhan, socializing with artists, writers, filmmakers, and photographers. The landscape there was so attractive that O'Keeffe returned in 1930 to spend another summer. Her arrival back at Lake George in September after more than three months away from Stieglitz was a cause for celebration. This study of her hands tenderly, almost erotically, caressing the skull of a horse is full of foreboding symbolism, however. The skull conveys the message that all things have a beginning and an end.

O'Keeffe had brought the skull back with her and made a series of paintings of it and other bones, the subject of her 1931 exhibition at An American Place. At about this time the subject matter of her paintings and Stieglitz's photographs began to overlap significantly, almost as though they had begun a private dialogue between themselves in visual language.

In this photograph Stieglitz apparently used a blue or green filter to darken the skin tones. The hands do not appear to be of the same flesh as the person shown in the next picture (pl. 47), but rather of someone of African or Native American ancestry. We can only speculate about what Stieglitz's motivation may have been in causing this transformation to occur.

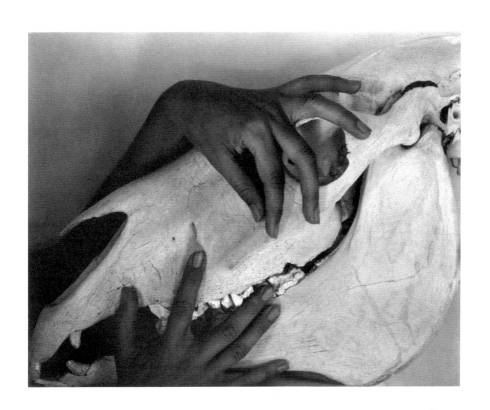

PLATE 47

Georgia O'Keeffe:
A Portrait
1932

Gelatin silver print
11.2 × 23.8 cm
93.XM.25.54

O'Keeffe was approaching her forty-fifth birthday and Stieglitz his seventieth when this photograph was created. Her physique could be confused with that of a younger woman, such as Edward Weston's teenage girlfriend and model, Charis Wilson. Stieglitz continuously reinvented O'Keeffe in his multipart portrait of her that had commenced fifteen years before. However, she was being photographed less and less, and after 1930 Stieglitz tended to avoid her face except in casual snapshots.

The interaction of such dualities as black versus white continued to dominate his imagination. Here the black patch of pubic hair contrasts with the white skin, and the sensuous curves of O'Keeffe's body contrast with the sharp edges of the picture. It was unusual for Stieglitz to crop a negative so radically, as he does here by removing much of the area from the top and bottom of the image.

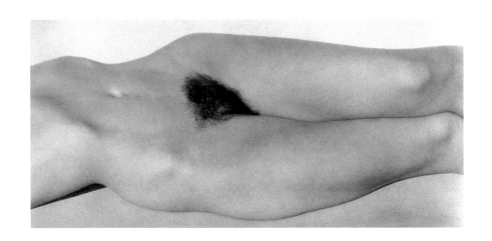

PLATE 48

Georgia O'Keeffe:
A Portrait
1933

Gelatin silver print
24.5 × 19.9 cm
91.XM.63.11

In the late fall of 1932 O'Keeffe suffered a
nervous breakdown, caused at least in part
by anxiety over a mural commission from
the developers of Rockefeller Center. During
1932 and 1933 almost all of Stieglitz's pho-
tographs not made at Lake George were
of Dorothy Norman, his young assistant at
An American Place, and O'Keeffe's per-
ception of their deepening friendship was
also a cause of anxiety for her.

O'Keeffe spent the last five weeks
of 1932 hospitalized in New York, unable to
receive visitors except on rare occasions.
After her discharge she traveled with the
photographer Marjorie Content to Bermuda,
where she stayed convalescing until May,
when she joined Stieglitz at Lake George to
continue the process. This photograph
may celebrate their reunion. O'Keeffe was
also overjoyed to be reunited with her new
Ford V-8 convertible, which was a symbol
of her absolute freedom. We can imagine
the irony Stieglitz intended in depicting her
affection for the vehicle by again employing
the motif of the caressing hand.

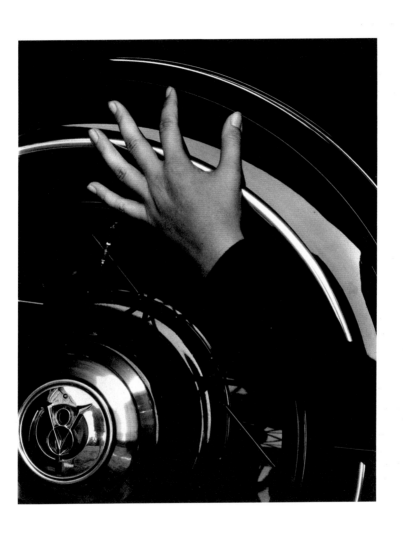

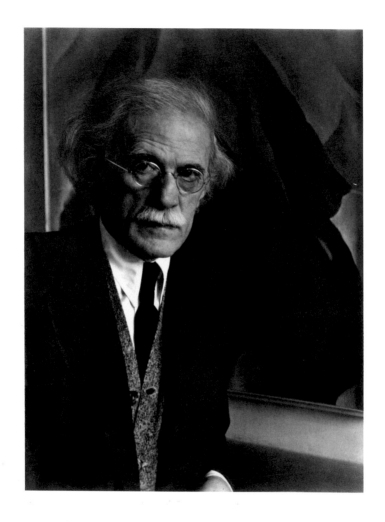

Imogen Cunningham. *Alfred Stieglitz at An American Place,* 1934.
Gelatin silver print, 24.1 × 18.3 cm.
88.XM.44.25.

Alfred Stieglitz:
An Affirmation of Light

Charles Hagen: Most people in photography have strong opinions about Stieglitz. I find it impressive that he is still so interesting, so rich a character in the history of our field. Perhaps we can start with a discussion of his early days as a photographer.

Sarah Greenough: Stieglitz started life as a technician. Science, and an understanding of the scientific process, really informed his life—the idea that in science you make a set of observations, set up a test to challenge those observations, and then draw your conclusions from them. Throughout his life he was continually making experiments, and it was critical to his photographs, the process of reinterpreting them, seeing what they would look like as a platinum print, a palladium, a carbon.

CH: He was definitely interested in science and scientific technique but also had a deep interest in the spiritual and the antimaterial. This seems to be a very German combination. He was raised in a German-speaking family and studied in Germany—what effect do you think this had in shaping his attitudes not only toward life but also toward photography?

SG: I think it was crucial. His home life was clearly very influential in shaping

him. His father's love of art, for example, had a great influence on the kinds of photographs Stieglitz made in Europe in the 1880s and 1890s.

Emmet Gowin: Didn't Stieglitz quit his physics class because he wasn't understanding the subject?

CH: My feeling is that he was perfectly capable of following the lessons, but that incident fit into the image he wanted to present later of himself as a simple man.

SG: As a student, he was really wrapped up in photography, and perhaps saying he didn't understand physics was an easy excuse. But it is part of the construction of the myth, in the same way that Stieglitz told Dorothy Norman that he never visited any European art museums. But that's not true. If you go to Yale, there are scrapbooks in which he kept copious records of such visits, and people are beginning to find logs of him signing in and out of various museums in Europe. It's all part of the story Stieglitz wanted to tell in the 1930s of who he had been in the 1880s. To a great extent, we know Stieglitz primarily through the images that he selected later in his life.

Weston Naef: Like many other photographers, Stieglitz seemed to have experienced a moment of rediscovery when he studied negatives that were made sometimes decades before. The negative becomes a kind of time capsule for the photographer.

CH: A basic fact for photographers who have long careers is that through their negatives they have access to their earlier work and can go back and reinterpret and shape what they were doing years before.

John Szarkowski: How many pictures of his are known?

SG: Well, the National Gallery has sixteen hundred of his photographs. And there are a fair number from the turn of the century that are known only through reproduction, perhaps twenty to thirty, and another thirty to fifty perhaps from throughout the rest of his career that we don't have. So maybe there are seventeen hundred images total.

JS: In sixty years or thereabouts.

SG: Georgia O'Keeffe once told me that at some point she saw four albums of photographs of Kitty, but they seem to have disappeared into the Stieglitz family, and they've never come back out, to my knowledge. She described them as albums that were perhaps six by eight inches, quite small, almost like the scrapbooks that any parent might make of pictures of their child.

WN: Let's move from Stieglitz's days as a student in Berlin in the 1880s to New York in 1893 and *The Terminal* (pl. 2).

SG: This shows the end of the Harlem streetcar line, going up and down Fifth Avenue. It was made in front of the old Post Office. Stieglitz said he made this picture shortly after seeing Eleonora Duse perform. As Stieglitz tells it, again in the 1930s, he had returned from Europe in 1890 and found New York to be a culturally barren place, and wondered how he was ever going to live in this desolation. And then, in 1893, he saw Duse perform, and found this experience so moving that he decided that even if he could only experience something like this once every three years, he could perhaps stay in this country.

The next day, as he tells the story, he was out tromping around New York, photographing, and came upon the streetcar driver patiently watering his horses at the end of the line. When he saw the streetcar driver nourishing his horses so they could continue their journey, Stieglitz decided that he should assume the same role and nourish the arts in this country.

CH: It's interesting how self-centered the story is. It has nothing to do with the horses per se. They are symbols for him of his own lonely situation.

EG: Yes, but it's just beautiful, particularly the edges of things. The way one thing fits into another—the shoulders of the man almost form the mouth and chest of the horse; the way the candelabra of the streetlights becomes part of the sort of Steamboat Gothic architecture of the car itself and mirrors the Greek Revival architecture.

This is a good snapshot, and it shows you what a snapshot might mean in a constructive sense. You think you're photographing the horses, but in fact it's the steam that's helping him tell about this reality.

WN: A curious aspect is that the main figure is seen from the back. But if the position of the figure had been reversed, the magic of this picture would be lost. We can also point to ephemeral details—the broom resting against the pillar. That is a wonderful touch that somehow balances the man striding up the street. It's a picture full of telling details that are hidden in a kind of messiness. In its messiness seems to lie the appeal.

CH: I disagree that it's a messy composition. I think he's playing a sophisticated game of angles, both in space and on the picture plane. The man and the horse on the right seem to merge into one centaurlike figure, and the car echoes the building behind it. But everywhere angles are aiming in different directions toward the picture frame.

SG: I recently did an exhibition, *Stieglitz in the Darkroom,* that was based on variations. The National Gallery's silver print of it is a contact print and has more at the top and the sides. It does become a messier composition, more like a snapshot. We also have a large photogravure of it from around 1910 that's more tightly cropped than this image and focuses more on the man and the horse; the details in the background are suppressed.

I think for Stieglitz it evolved from being a snapshot to being something that he attached extraordinary symbolic importance to in the late 1920s and early 1930s. When he makes the later silver print of it, he is able to show more of its messiness; he is able to accept the snapshot as the work.

CH: How big was his camera here?

SG: This is from a four-by-five-inch negative.

CH: Were the pictures he did on the streets in the 1890s made with a hand-held camera?

SG: Yes, probably with his four-by-five-inch Graflex.

JS: I don't think it's a Graflex. It may just be a four-by-five-inch hand camera with a window. Of course, when we say Graflex, we mean generic Graflex, a big single-

lens reflex hand camera where you see the image accurately and to the edges. They were just coming into manufacture at that time. I'm not sure Graflexes as such existed yet.

WN: This picture combines Stieglitz's urge for social documentation with the urge to document the picturesque aspects of New York. The trolley looks back to the way transportation would have been for fifty years prior to this picture. So it seems very nostalgic, as if he were looking back at a perfect past.

CH: I've always wondered whether Stieglitz was aware of the social implications of *The Terminal* and other pictures from this period. Was he commenting on the coming of industrialization and the passing of animal-drawn vehicles? Or was he attracted to the scene because of the formal element of the steam or, in other works, the smoke?

SG: I think he's fascinated with documenting New York City and, particularly by the turn of the century, with documenting its transformation from a more nineteenth-century place to something that is being radically altered right before his very eyes.

JS: He's interested in the social life of the city, but in a rather abstract way. There's a passage where he talks about going out in the street and, in effect, being nourished by observing the common people. It's a rather odd confession, I think.

EG: This is also the time of the Ashcan school of American painting, which had a somewhat patronizing, reformist attitude.

SG: The Ashcan school is a little later, but these have that same spirit.

JS: I think, though, that the Ashcan painters made a greater effort to identify with as well as take vitality from their contacts with the lower classes.

SG: Yes, but they're engaged in the same search for, as Stieglitz himself called it, "picturesque bits" of New York and other places.

JS: Is there any reason to think that Stieglitz thought that this picture was a success? Is there any record of it ever having been exhibited or reproduced?

WN: This is a photogravure in the large size from about 1915 from an 1893 negative, so it was obviously something he thought worth revisiting. It is also a very beautiful object and a masterpiece of photomechanical printing.

EG: On the question of Stieglitz's social awareness: he had a strong belief in craft, a belief in the direct reciprocity between what one was and what one made, that the quality of one's acts were related to the quality of one's products. I think that represents a social longing on his part that wasn't being responded to by the twentieth century.

This was probably the sense in which he rediscovered these pictures, accepting them as things that were no longer in touch with the quality of one's individual acts, but anonymous things produced by a machine, with their own intrinsic qualities. Like the Futurist view of the car as a machine, these were, in their "machineness," interesting again.

He wasn't able to follow through on any of the things that he set out to do. He wasn't able to change New York's appetite for art. He wasn't able to ingrain in people a love of art. So in a way, he was a failure. If he had a social strategy, part of it was to show people that art could remake their lives. And he had to recognize that he was a failure at doing that.

WN: I was attracted to this picture because it calls to mind reportage that was first seen in New York about 1890. For me, this is a picture about the questioning of one's direction. Through the photograph he poses a question in pictorial language: Is he going to be an art photographer influenced by European Biedermeier painting or is he going to be a documentarian? Or is he going to be something else?

CH: In the work from this period I often see him as a sort of technical athlete, going out and testing himself continually, so much so that sometimes the pictures are hard to see for their pictorial interest, because you are so aware that he's trying to do something technically difficult.

JS: One of the things that saved Stieglitz from his most outrageous essays into persona building was his deep and genuine interest in photographic technique. He really was terribly taken with the problems of making clear and coherent images

under various difficult circumstances. All the night shots, the bad weather shots, the whole series of circumstances that were not easy circumstances, where one had to improvise and hope for the best and push the technique to someplace near the edge of the envelope.

CH: But, Emmet, your point seems to be that he could go back thirty years later and recognize that this picture, which seems more snapshotlike in its composition, might be as interesting as other pictures that at the time were considered more successful pictorially and were widely exhibited.

EG: This was surely meant to be cropped. He had to take the picture at the instant he saw it, because the coach was approaching and his time was limited. Stieglitz tells of the day he found these negatives; he had thought they were lost. And he set about to print them. He recounts his emotional excitement at things that he would have seen entirely differently when he was younger. And he made contact prints. Instead of something grand, these are tremendously intimate.

It was as if he rediscovered himself. But he rediscovered something else, that in reconsidering the past, reevaluating it, he had to make it into something new.

You're different people at different times in your life. And he was given a second chance. As a maker of images, you always hope there's a second chance!

WN: Let me read something that Stieglitz wrote in 1938 that's pertinent to what John was talking about: "It's difficult to understand today the passion and intensity I poured into Photography during those early years. I spent hours, days, weeks and months. Photography had become a matter of life and death to me."

Let's turn our attention to another early image, *The Hand of Man* (pl. 4). Have you ever seen a platinum print of this, Sarah? I never have.

SG: No, but I believe one was auctioned at Sotheby's in 1981.

WN: But isn't the first and therefore definitive state of this picture the gravure that appeared in *Camera Work* in 1903 (p. 111), the year after it was made? Usually we think of platinum or silver prints as being the definitive states, not those created photomechanically.

SG: There is a significant difference between the gravure that was made for *Camera Work* in 1903 and later prints. In 1910 Stieglitz made a larger gravure of it, probably for the Albright Art Gallery exhibition, but maybe in anticipation of making a portfolio of views of New York. And the difference between that and the 1903 *Camera Work* gravure is extraordinary.

If you look carefully at the *Camera Work* gravure, you can see that he actually re-etched the plate in order to suppress details of the railroad tracks. And it's very dark. In the 1910 gravure he lets the rails come out, and it becomes this electrifying, far more Modernist image that celebrates the power of the machine and the industrial environment. That 1910 gravure is closer in feeling to the later silver gelatin prints, which seem to have been made between about 1924 and the mid-1930s; a lot were made for the mini-retrospective exhibitions that Stieglitz had at An American Place.

JS: I have never seen these two versions next to each other before, and it's absolutely fascinating. All the active parts of the picture run right through the middle ground, so he has to go out of his way to suppress the dramatic light on the rails. If you print it dark, as he did in the later image, the rails make the picture flat, but in a different, more Modernist way. The earlier version has more of an Impressionist flatness, with those spots across the middle distance.

EG: I've often thought about Stieglitz's tendency to pick out a singularity from a scene that stands off as a kind of loneliness, almost like a self-portrait. Not only does he identify with the Modern in these pictures, he also seems to have been slightly run over by it. There is a coldness, a loneliness, about even this thing that is extremely beautiful.

In the 1903 version the engine in the background pushes forward. In the contact print the engine recedes into the distance. The picture creates its loneliness in another way, but it submerges the content of the picture; it reduces the sense of the singularity of the life of the engine.

JS: Tell me, Emmet, which do you think is more successful?

Alfred Stieglitz. *The Hand of Man* (detail),
1903 photogravure from a 1902 negative.
15.8 × 21.4 cm.
93.XB.26.1.

Alfred Stieglitz. *The Hand of Man* (pl. 4, detail),
1930s gelatin silver print from a 1902 negative.
8.3 × 11.2 cm.
93.XM.25.7.

EG: I see them as different symbolic portrayals of the same thing, Stieglitz's essential loneliness. I like them both—one is the person trying to realize himself in the world in one way, and then as he got older and darker and more distant, the other is a more mature way of looking at the same thing. That's what I was trying to get at before. He was different people at different times in his life.

WN: This is a print Stieglitz gave to O'Keeffe. I think this image, which she first saw in *Camera Work*, was the first Stieglitz that left a strong impression on her; she made a watercolor based on it. He didn't see it at the time, so he probably didn't learn of her admiration of the picture until later.

SG: The painting is *The Train in the Desert;* it's at the Museum of Modern Art. She painted it in 1916–17, when she and Stieglitz were in correspondence and he was sending her back issues of *Camera Work.* O'Keeffe was certainly moved by

this image, but she was in Texas, traveling around mostly by train. So the painting blends her experiences of the railroad with this photograph.

CH: I find this a very bleak image—the scene is so desolate. At the same time, in other pictures from that period, he seems to celebrate industry.

SG: The title makes it even bleaker; this is what the hand of man hath wrought. The *Camera Work* gravure seems not to be something that he was proud of, but when you look at the large gravure from 1910 and see the beauty of those rails, it seems almost as if the city has become a positive thing for him.

WN: This is one of the first pictures that he recognizes almost immediately should have an audience. He makes it in 1902 and publishes it in 1903. *The Steerage* (pl. 6), however, which also comments on modern life, was made in 1907 and apparently not printed until 1910 or later.

SG: Stieglitz made a gravure of *The Steerage* for his 1913 exhibition at 291, and he made two more gravures of it for the publication *291* in 1915. It's in *Camera Work* in 1911. There's a story that Marius De Zayas and Paul Haviland were looking through a batch of Stieglitz's old proofs and commented upon the extraordinary formal quality of *The Steerage*. It was this that triggered Stieglitz to make a real print of it.

WN: I am always dazzled by the perfection of this composition. It is built like a puzzle with each of its parts dovetailed into its mate. Sarah, you have studied the several surviving prints of this. Are we seeing all of the negative or is this a post-visualized creation?

SG: There are five prints that are all more or less four by five inches. So one would presume that they are contact prints from the negative. And they are all cropped more or less the same.

WN: It is a miracle! Previsualized edge to edge in such a perfect way. It may be worth reciting what Stieglitz wrote about this photograph: "The scene fascinated me: A round straw hat; the funnel leaning left, the stairway leaning right; the white drawbridge, its railings made of chain. . . . I stood spellbound for a while. I

saw shapes related to one another—a picture of shapes, and underlying it, a new vision that held me."

He, of course, recalled these experiences many years after the picture first appeared in *Camera Work*. This leads us to imagine how much he had learned from Modern art between taking the picture and analyzing it.

JS: He's not remembering what he saw in the ground glass in writing that in the 1930s. He's looking at a picture! In the first place, the funnel wouldn't be leaning left; it would be leaning right. The picture is laterally reversed in a Graflex.

SG: To me, that comment always sounds like Kandinsky describing a painting. It's very formal. But I don't think it's the way Stieglitz saw the photograph.

JS: It's the way you talk when you look at a picture you've already made.

SG: We need Beaumont. Beaumont Newhall, the great historian of photography, spent months, years, working on this image. He got pictures of the ocean liners Stieglitz was on. He had someone chart where the sun would have been on this trip, in order to prove whether Stieglitz was going to Europe or coming back from Europe.

I think with this picture there might have been social implications, though. Stieglitz likes to recount how he felt constrained by the social circle that he had to travel in with his first wife. And I think the same story also says how he didn't like going in first class, which is what his first wife wanted to do. He found that there was a lot more going on in the other classes of the ship.

One of the first times it was published after *Camera Work* was in a small New York newspaper, where it was called *Outward Bound: Beyond the Quota.* Again, I was just thinking about this in connection with Beaumont, because it was Beaumont trying to figure out which direction the ship was traveling in. But "beyond the quota" means that these were people who were being sent back to Europe because the quota had been met. It always seemed to me highly unusual that at that time, and I think the publication was in 1911, Stieglitz would have let somebody else put a title on his work. So I wonder if he wasn't thinking about this with some slight social connection.

WN: Sarah, do I understand that you believe this was made when the vessel was traveling eastbound?

SG: Yes, the boat was on its way to Europe.

CH: For me, the psychological story of the picture is the man looking down into the steerage. It's hard for me to avoid identifying that person with Stieglitz himself.

JS: I know nothing about the facts. Are there two levels of steerage, upper class and lower class? If so, are they on different levels? Is this really the same boat Stieglitz is on? What is he looking down into? What is this huge, open hole? What is this gangplank? Iconographically, this picture is an absolute mystery to me. If it weren't for all the stories, I would think this is a different boat or they're in dock.

SG: That was one thing Beaumont ruminated on. Do you hang up your laundry when you're crossing the Atlantic and there is the spray of the ocean? It does seem more as if it's a boat at rest than a boat that's moving. Also, the people on the upper level don't look much more prosperous than the people below.

EG: Well, obviously, except for the man in the straw hat, who seems different from the others. The space between the figures does not speak of prosperity. I always thought that Stieglitz was standing on the level that the gangplank crosses on. Both levels are steerage. They both represent dense passage without staterooms.

JS: How much of our critical energies should we devote to wondering whether a recollection made late in the day under trying circumstances was completely accurate? There must be a better way to get at the meaning of these works than to spend our lifetimes wondering whether or not Stieglitz had it quite straight when he was remembering what he thinks he remembered. I know that doesn't get us very far—except maybe back to the picture.

SG: Well, but there are obviously levels of meaning in this photograph. It may have had one meaning to Stieglitz in 1907, another to him in 1911, another in 1915, and an entirely different one in 1930.

And then it has meanings beyond that. We see it one way today, which is

different from how it was seen in the past and how it will be seen in the future. And that's the richness of it.

JS: Yes, but what makes all those meanings possible, and makes them, to a greater or lesser degree, valid, is the fact that there is a continuing meaning, which is the picture, which exists in the real world, and which is interesting enough that we want to continue to look at it and try to figure out what it might mean, whether or not they are immigrants or emigrants, sailing or standing, or going west or east, and for whatever purpose.

Because as interesting as the other questions are, it's very likely we're never going to know the answers for sure. If Beaumont didn't get it pinned down, we're not likely to do so either.

CH: The circumstances of the scene may be different from the implication of the picture itself. For me, this picture is basically about two levels: upper and lower. For a long time I assumed that the upper level was the first-class passengers and the lower level was the steerage passengers. After a while, you start to notice that the people on the upper level are equally poor, and so it's not quite as simple as that. The central figure, as I said earlier, seems to come from a different class. But most of the men are on the upper level and most of the women and children are down below.

WN: On one hand, the straw hat is an incredible shape that we know is a hat, but on the other hand, it also looks like a machine form. It looks as machinelike as the chains, because of its geometry.

For me, it's once again a picture about destiny—the destinies of these people, the destiny of Stieglitz. This is 1907, which was an extraordinary year in his life. It was the year he discovered Picasso and made his first color photographs. It was also the year he made a Rembrandtesque self-portrait (p. 7). Here is the man himself in the year that he made *The Steerage,* a person full of ego, an incredibly interesting human being. What a head of hair he's got! What a moustache! *The Steerage* was taken at a time when this man was asking himself very hard questions about his own life and his own existence.

According to Stieglitz's version, he made this picture on the way to Europe. He arrived there and saw his first Picasso painting; he was handed a Lumière color plate and had to decide whether he would fall completely in love with color photography and whether he would ever make another black-and-white picture.

But this is where the facts of the picture are important. If he made *The Steerage* on the way to Europe, before he saw his first Modern painting and his first color photograph, then the sense of destiny about the picture is much stronger.

JS: I don't see any reason to disallow the fundamental thrust of what he is talking about. Whether he is looking at the print or remembering the act of looking in the ground glass, he's talking about a picture that's made up of trapezoids and triangles, a picture whose fundamental meaning is dependent on the entire sheet from corner to corner. He's talking about it as an abstract picture. And it's a terrific picture! It still is a very vital picture.

WN: Would you say that this photograph is the beginning of Modernism in photography?

JS: Oh, no. That's too arbitrary, too dictatorial. It assumes that Modern photography begins at one second, when one person pushes the button on one camera. And there's no reason for making the story so ungenerous as that.

EG: I like what John said about getting back to the picture. I remember something Stieglitz is credited with saying, that "what a person believes is more real than reality itself." I have lots of reasons in my experience to believe that's so. But Werner Heisenberg said that "reality is stronger than our wishes." They sound like absolutely opposite points of view, yet they both represent something worth thinking about.

That's what John is saying about *The Steerage*. It represents something architectural, pictorial, geometric, which is moving the way music is moving, that before you have any idea of what it means, it's moving. And embedded in this beautiful structure are countless instances of humanness, expressed through body stance, gesture. The picture is both an abstraction and a structure, like a

piece of music, but where the notes would appear on the score are these beautiful gestures of humanity.

SG: As Emmet was talking, I saw this picture in a way that I hadn't before. There are little bits of this picture that are quite sentimental, the people with the shawls, for example. If Stieglitz had only photographed them, the image would become trite. But it has that extraordinary structure on top of it that holds it all together.

JS: You know, another thing about this picture is that it is half Picasso and half *Waiting for Godot.* There's nothing happening in it. There's the patience, the waiting, this dumb kind of brute waiting. And all these terrific little portraits. A dozen portraits locked into this wonderfully resolved architecture. And they are all worth looking at and thinking about, wondering, do we know anybody related to any of these people? Did any of them make it?

WN: Are any of them our ancestors?

CH: There's a positive-negative flip that goes on too. The top is mostly black on white; the bottom is mostly white on black. The only figure on the top who is white on black is that man in the straw hat again.

JS: Absolutely. Look at the negative shapes of the white sky in the upper half as compared to the shawl of the woman with the stripes in the lower half. The shapes in the lower-right-hand corner are the same shapes as in the upper-left-hand corner. The whole thing is like a great jigsaw puzzle—it just snaps together. That makes it sound vulgar, but it's absolutely one piece of cloth.

WN: But if this picture was created with a flash of recognition that a masterpiece had been created, why did he wait four years to print it?

EG: A pictorial structure is a nonlinguistic event. And it's not surprising that when we try to point at it, it doesn't spring into words. Because it isn't words. It isn't a set of want-to-be words. It's a powerful thing.

JS: It's all intuition. If you take a half step to your right, everything changes; if you take a half step to your left, everything changes; if the sun is veiled, everything

changes. There is no opportunity to stop and analyze all of these things. As Emmet said about *The Terminal,* it's now or never, and if you think you've got a chance, you take it, and once in a while you're lucky.

EG: What must make a photographer almost dumbstruck with good fortune, again and again, is that the plate goes as far as it needs to go, and only that far. If it had gone any less, the power of what's gathered there, and the way it resonates as an engine of unity, would collapse.

WN: Can we go now to a picture of Stieglitz's daughter, Kitty, seated in a park (pl. 7)? Let's assume that the boat is heading eastward, that in five days they are going to arrive in Liverpool, and that a week later Stieglitz and Kitty and Emmeline are going to be in Paris. This picture was probably made after they had arrived in Paris.

SG: In the National Gallery there is an autochrome of Stieglitz and Kitty that is supposedly by Stieglitz. I think it could as easily be by Steichen or Heinrich Kuehn or Frank Eugene. It is a picture of Stieglitz and Kitty sitting on a bench; Stieglitz has a long wooden tripod resting on his lap, with his camera on top of it, and Kitty is sitting next to him. Stieglitz is looking intently at her. That image speaks much more about Stieglitz as a photographer, how he looked at the world, his relationships with other people. I see this as much more one-dimensional, flat.

EG: Almost a theatrical picture.

WN: Oh, it's very theatrical. This is almost like Broadway. This is the sort of thing that all the studio portraitists would have made.

EG: I would much rather look at a sheet of Stieglitz's handwriting than this.

WN: There seems to be an incredible gulf between *The Steerage* and this. This was a picture of possibly the most pressing reality in Stieglitz's life at this moment, which was his daughter and her future. This is incredibly autobiographical.

JS: How do you know it's in Paris?

WN: Because that was where he obtained the Lumière autochrome plates and made the first experiments with them. But we don't know for certain. This could

have been in Innsbruck, Austria; or in Munich; or elsewhere.

SG: Someone should get all the autochromes by all the members of the Photo-Secession together and start identifying the locations and trying to figure out who took what. Interestingly, there are a lot of pictures of people sitting on benches. Did they go to parks because parks had flowers that were nice to photograph with autochromes? There are a lot of interesting issues that need to be addressed here.

In so many of Stieglitz's pictures of Kitty from this time on, and particularly in the autochromes, you see such a hesitancy in her, such a distance between her and Stieglitz. There is a sadness to her look that makes me think of a sadness in her relationship with him.

EG: Well, he's trapping her in a role, and she doesn't want to be in that role.

CH: After the fact, we would like there to be a fairly clear progression in an artist's understanding of his or her own work. But in fact, that is often not the case. People have different ideas in their heads at the same time. He could go back and forth between *The Steerage,* which seems to be so much of a break with what he'd been doing before, to something like this, which is much more traditional. Also, it's interesting to think about the differences between his public and private pictures, with these two pictures reflecting those differences.

SG: He's also trying a radically new process and materials.

JS: If you're a photographer and somebody tells you that you can put this plate in your camera and get a color picture, one shot, not three plates with filters, that's going to be extremely interesting to you. And if your daughter is handy, fine.

WN: And if she happens to be holding flowers, all the better.

EG: I have to agree with Sarah that she seems reluctant. It almost feels like a fashion picture. If I didn't know that Stieglitz made this, I would not have any reason to associate it with my image of him. I'm sure she was really important to him, but I wouldn't know it from this.

JS: The nicest part is the wonderful shape of the white dress.

CH: The butterfly net echoes Kitty, the circle being the head and the white of the net being the same color as her dress.

WN: That net struck me as being intentionally symbolic, really echoing the girl.

A number of autochromes were together in a group that came to the Getty, the balance of them being of Emmeline Stieglitz (pl. 9). They have an incredibly melancholy sense about them and are, as compositions, barely formed, as though Stieglitz simply did not wish to concentrate on the problem of making a picture. They may have been simply experiments in using the autochrome process. But as an interaction between two human beings who had been married for almost twenty years, they're a terrible failure.

JS: How long did he continue his experiments with Lumière?

SG: From 1907 until 1916.

WN: Was there anything much in between?

SG: There are some family shots from 1914. Kitty is a good marker, because she appears in quite a few of them, and she obviously grows older as the years progress (pl. 8). He seems to have gotten packages of the autochrome material at intervals and experimented more with it.

WN: Between 1911, when *The Steerage* was published, and 1916 or thereabouts, when the next pictures we're going to see were made, Stieglitz was in a creatively fallow period and realized relatively little work. One of the highlights of the small body of work that was created was the series of studies out the back window of 291 (pl. 15).

Stieglitz was an admirer of the opposite sex and made some of his best pictures of women, especially of women much younger than he. Here, in these photographs of Ellen Koeniger in a wet swimsuit (pl. 16 and p. 121), we see his love of light and his love of a motif resistant to his materials: black bathing suit, bright light.

JS: The smile is the most conventional part of this picture (p. 121). What makes it so incredible is that happy, innocent, conventional depiction of an all-American

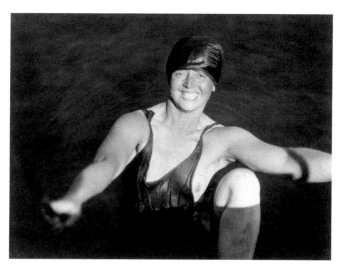

Alfred Stieglitz. *Ellen Koeniger,* 1916.
Gelatin silver print, 8.8 × 11.9 cm.
93.XM.25.5.

girl, or face, and this insane animal creature from the chin down. You could take the bottom half of the picture and divide it in two. Say you just had the lower right corner, you might not be able to read it. And the same with the lower left corner. The photographic drawing in this picture is extremely radical. I mean, it's really a picture out of control.

WN: This is a picture that I have often puzzled about. What if it had been in focus in a different way? What if her smile had been slightly different? What if her swimsuit had not been as revealing as it is? Once you start going through the "what ifs," you realize that it's a kind of miracle that what we're seeing is even the way it is.

JS: But it's extremely instructive as a photograph. It's a great object lesson about how to think of interesting photographs that may not be quite so radical in their description as this. I think he could only see this picture in the broadest outlines. He's probably so enchanted with this great smiling face and this great wet thing—

this wonderful wet thing getting out of the water with a big smile—that's what he sees, then he goes "bang." But it's so profoundly flawed.

CH: Are there other pictures of his from this same period that have this radical deformation of the subject?

JS: There are a number of these swimming shots, of girls getting in and out of the pool.

SG: It always seems to me that this is a photograph that Stieglitz has captured without realizing what he got. There is no way he would have seen the foreshortening in the arm. There are lots of pictures of Ellen in the water and others where she's on the dock, and she's dancing, literally, for Stieglitz in the same way that O'Keeffe would later do. And Stieglitz is obviously just happily snapping away. But the fact that when he went to make a print of this, he saved it—that is where I think we can see the influence of Modern art, in the idea that there is some validity for accepting a composition like this.

JS: And he didn't crop it. He could have made a much more conventional picture, just of her head and shoulders.

EG: I think Stieglitz learned greatly from all those exhibitions he did, that he got his education in form by running that experimental station in the gallery.

Something else, in passing: I always respect Stieglitz tremendously for trusting Edward Steichen. He admired Steichen as someone who admired painting and photography. Steichen's enthusiasm was enough to help him see that Rodin was terrific, and all this other stuff. What is it that Steichen called Picasso? A "crazy galoot"? I think that's great. But it's almost like affectionately accepting Picasso as someone to be learned from.

SG: For Stieglitz to learn from younger artists too, from Paul Strand and others, shows a real generosity.

EG: All those days he spent in the gallery promoting the welfare of Arthur Dove and John Marin and O'Keeffe and all those other people shows the same kind of generosity.

I saw eight or ten of these bathing pictures at the National Gallery about 1968 or 1969. I heard that there were a group of pictures that were never to be seen until O'Keeffe was dead, so of course I wanted to see them right away, because I figured anything that was that big a secret must be really good. And I saw these and thought, "Wow, maybe these ought to be in the envelope too." I didn't think anybody would show them, they were so sexy.

CH: Were these shown at the time?

SG: Some of the nudes of O'Keeffe were shown in the 1920s. Stieglitz always said that he withheld some because New Yorkers weren't ready to see them. But I don't know if any of these were exhibited.

CH: They can be read as expressing an attraction and fear of a woman as a sexual being. She's like the mother of Grendel coming out of the marsh.

SG: Is it fear or awe?

JS: Awe, yes. But tinged with fear. Because real sex has something to do with mysterious powers. It's not just fun and games. And these pictures have got something to do with that kind of out-of-the-swamp authority.

WN: At this point, neither Freud nor Jung had been translated into English, so Stieglitz would have read them in German—which Sue Davidson Lowe said he did. It's not until the O'Keeffe pictures that we really come to a clear reading of the opposite sex in terms of Freudian sensibilities. This has more to do with the kind of sexuality that Wagner was dealing with. We know of Stieglitz's love of the music of Wagner. References to creatures rising from a primordial soil are evocative not only of this picture but also of the emotional reality behind Wagner. I am trying to demarcate a change in Stieglitz's life. Starting with the first O'Keeffe portraits, his pictures take a very different direction.

EG: This photograph (pl. 16) is organized the way one organizes a portrait. Where the mouth, eyes, and nose are normally located, there is something not unlike a beast with a face. It's grounded just enough by the fleshy legs to let you be sure of

where you are. Get rid of that, and you might start to wonder whether you were suffering an apparition.

WN: It also recalls Classical sculpture, where the diaphanous garment clinging to the skin was part of what the sculptor was asked to record.

EG: I don't think you could go to a public beach like this.

WN: This was about the time that Stieglitz went skinny-dipping himself with Max Weber and others. He became so intoxicated by swimming in Lake George at night that he wrote a number of letters exclaiming how beautiful the experience was. In fact, one of the stories is that he got Weber and De Zayas to travel up to Lake George—neither of them liked the country that much, and they normally didn't go to Lake George—specifically to go skinny-dipping at night. I think that was also in 1916.

CH: The woman looks to me the way a bronze sculpture might look in a photograph.

WN: We assume that these pictures were taken in August 1916. The next year he made his first photographs of Georgia O'Keeffe at 291. From the beginning those are vastly different from most of his earlier pictures of women, although they do have, in my mind, a strong relationship to the portrait of his secretary, Marie Rapp, in her hat (pl. 17). Here we see O'Keeffe, similarly dressed in her town outfit (pl. 20). Stieglitz, though, focuses not on her face, but on her hands, which become like sculptures.

I also find the relationship of triangles that we saw in *The Steerage* coming back here. There's the triangle of her blouse, the triangle at her left elbow, and then the eccentric curved triangle below her forearm; they seem such wonderful miracles.

JS: Her hands really are extraordinary. Her fingers describe arcs, sections of circles; other people's fingers don't do that. They come in straight lines and they bend. It's astonishing, too, how many of the portraits really are hand studies. Clearly her hands are posed. I don't think these are gestures she just falls into, or maybe she falls into the beginning of them and he says, "Now raise this one, turn

that one, pull this elbow back a little." They are very artificial—beautiful, but extremely constructed. Did she ever say anything about the fact that the hands figure so prominently in the series?

SG: She wrote about posing for Stieglitz and how she would have to sit for three or four minutes.

WN: She also wrote that people had admired her hands ever since she was a little girl. O'Keeffe was clearly very conscious that she had special hands.

CH: Do you think the emphasis on her hands in the portraits comes more from her than from him?

SG: I have very strong feelings about Stieglitz's portraits of O'Keeffe. Some art historians have called these pictures O'Keeffe's greatest performance, as if the way she is depicted is as much her doing as Stieglitz's. To me, that is utterly preposterous, an absurd notion. No one would claim that Rembrandt's portraits of Saskia are Saskia's understanding of who she was; they are Rembrandt's interpretation. O'Keeffe was clearly a willing participant in all of this, but it's Stieglitz's view of her. Stieglitz decided when to photograph, what to photograph—not O'Keeffe. She could provide the stimulus, and the hints. But when you see pictures of O'Keeffe by other people, you see a totally different person than in Stieglitz's pictures.

Rarely in Stieglitz's pictures do you see O'Keeffe smiling or laughing. She appears as a femme fatale, a person who exudes an amazing sexuality, a sexuality that can crush and destroy. Or she is this childlike, innocent creature who needs protection. Rarely is she anything in between. But if you look at other people's snapshots, you see that in-between person much more. It wasn't O'Keeffe who said, "Here, let me jump up on top of this radiator and dance about in the light for you." Stieglitz put her in those situations; nine-tenths of the time it was Stieglitz posing her.

JS: But surely the whole thing is to some degree a collaboration.

WN: O'Keeffe told me once how Stieglitz got her to pose on top of the radiator. She admitted that she was yielding to his suggestion, that she was the mannequin, and responded to his urgings.

However, this picture is such a total symbiosis of both of their instincts. He's cajoling her into a pose, but her own spirit comes through in the curving fingers, the way she positioned her hands. So this picture seems to demonstrate their collaboration.

EG: If you didn't know who this was or who made the picture, you would still be left with two profound shapes in these hands. The hand on the bottom is a receptacle, suggesting a kind of womb consciousness. The other hand suggests a breast consciousness. Not only is she touching and referring to her own body, she is referring to the function of her body through symbolic gestures.

This made me think of a story, which may be apocryphal. When O'Keeffe went to 291 during her first exhibition there, she supposedly told Stieglitz to take the pictures down, because he had not asked her permission to display them. He told her that you can no more take back a work of art than you can ask a child to go back into the womb and not be born. This is an unusual thing to say to a young artist.

WN: My reading of this picture is that it's at the very beginning of their relationship, before any of the nude studies.

SG: This photograph was made in early June 1917, when O'Keeffe, unbeknownst to Stieglitz, decided to come back to New York to see the exhibition that he had up of her work. He had actually taken it down by the time she got there, so he put it back up for her to see. She was there, I think, for five days. And from her letters to various people, it's clear that although she greatly admired Stieglitz, she was much more interested in Strand at this moment, as far as physical attraction is concerned. She wrote in a letter, when she came back from this trip, that she was afraid to be left alone in the room with Strand, not because of what he might do to her, but what she might do to him.

CH: This seems a very asexual view of a woman. Her dress is prim and proper. Both of your readings are of a woman with a capital *W*, as a mother, let's say, not as a sexual partner.

SG: There is one picture made at the same time of her with a hat on, and another without a hat on. She looks like a schoolteacher, with a very quizzical look on her face, as if she's not quite sure what to make of this great person or of his attention to her. In the 1917 pictures she looks like a schoolmarm from the plains of Texas. It's only when he focuses on details of her body that sensuality begins to come through.

EG: She is pointing to herself the way figures in Renaissance paintings touch themselves when they want to tell you of some kind of mystical connection, as when Mary points to her belly. O'Keeffe refers to herself as if she were an abstraction of the body.

SG: I'm always amazed when I look at these. O'Keeffe's body at times seems so monumental, and in other pictures you see what a delicate, thin person she was. That Stieglitz was able to transform her from this almost Amazonian woman to a frail, delicate little thing is really quite extraordinary.

CH: She had an extraordinary physical presence. Her head was big; in many pictures it seems out of proportion to the rest of her body.

WN: O'Keeffe was the exact opposite of contemporary ideals of feminine beauty. She was short, with short legs and a long waist. But Stieglitz managed to make her appear to have classic proportions.

JS: It's hard, in looking at these, to put aside the fact that this is O'Keeffe and the photographer was Stieglitz. They are drenched in myths and expectations.

SG: I would be careful, though, about saying that the theatrical aspects of some of these portraits is a reflection of O'Keeffe and how she wanted to be seen. That first summer at Lake George, O'Keeffe was thirty-one years old and Stieglitz was fifty-four. He was the world's most famous photographer, certainly the most important person in the New York art world. O'Keeffe was a nobody—a schoolteacher from the plains of Texas. So if Stieglitz said, "Lie down in the grass, turn your head, look up at me," or "throw your head back in this way," of course, she would take that direction. She was enamored of him. They were deeply in love.

WN: You're saying that at this time Stieglitz was in control, whereas when we knew O'Keeffe in the 1970s, she was in control of every situation! We can easily project onto this situation what we saw of O'Keeffe, but I think you're right to emphasize how much Stieglitz was in control.

EG: Do you accept O'Keeffe's belief that Stieglitz was pretty much always photographing himself?

WN: Oh, absolutely.

SG: Exactly.

WN: Of course, every picture Stieglitz made of O'Keeffe is really a portrait of himself. But in fact, what we're seeing is Stieglitz's dream of a woman. He was attracted to women, and each of these is a different kind of woman that he may have been attracted to at some point.

JS: Sarah, do you think she finally got tired of posing?

SG: Oh, yes. She got tired of it by the 1930s, certainly. I think she was tired of Stieglitz, tired of the family life at Lake George. She was tired of Eastern scenery and wanted to get West. She wanted more freedom. But I also think that after Stieglitz showed his portraits of O'Keeffe in 1921 and 1923, the critics began to pick up on the sexual aspects of her art and to criticize her paintings in terms that were often more appropriate to Stieglitz's portraits than to O'Keeffe's paintings. I think she saw how the persona that Stieglitz had established for her was affecting the interpretation of her paintings, and she pulled back and said, "I'm not playing this game."

Stieglitz photographed O'Keeffe almost manically from 1918 until 1922; beginning in 1922, he began to photograph clouds more. He exhibited the O'Keeffe portraits in 1921 and then her paintings in 1922. That's when these criticisms started. Stieglitz began to turn from O'Keeffe to the clouds, but I think O'Keeffe began to turn away at the same time from Stieglitz.

There's a steady decline after 1922 in the number of pictures of O'Keeffe, with very few from 1924 to 1929 or 1930. They pick up again around 1930, when

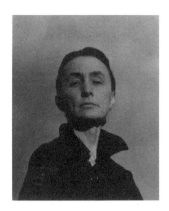

Alfred Stieglitz.
Georgia O'Keeffe: A Portrait, 1929.
Gelatin silver print, 5 × 4 cm.
93.XM.25.26.

you get the studies in the car. In 1932 O'Keeffe had a nervous breakdown, and she was at Lake George more. But there was always a barrier between them then. She just wasn't playing the game anymore.

I knew O'Keeffe toward the very end of her life. She really only made public comments about Stieglitz's pictures of her at the end of her life. And then she often said how she felt at the time, as if she were looking back over somebody else's lifetime, something that had no connection to her. There are a few snippets here and there in her letters where she briefly mentions a Stieglitz portrait of her. Usually they are derogatory. There are a couple where O'Keeffe says, "Oh, he made a particularly cowlike portrait of me"—an interesting description!

But I think later on she was scrupulous in that if Stieglitz made the print and mounted it, she valued it. I have never found any indication that she censored them in any way, either because they were too racy or she didn't like the way she looked.

EG: I'm very happy to hear that. When I was young, I heard that she x-ed the negatives, and I never knew whether that was true or not. It made me cringe. It was like having your body x-ed!

SG: I think what she did or didn't do with the negatives is different from what she did with the prints. To me, the way she disposed of the Stieglitz estate is an extraordinary demonstration of her recognition of Stieglitz's importance. She could have kept all those photographs; she could have given them all to one institution; she could have divided them up evenly, two hundred to every institution across the country. It really showed a deep understanding of his work that she kept together the so-called key set at the National Gallery of Art. She knew that it would be very important in the future to have one place where you could see 99 percent of Stieglitz's work from beginning to end. She recognized that different kinds of prints made from the same negative were different interpretations and not just multiple or duplicate prints. I think it shows extraordinary insight and respect.

WN: Can we turn our attention now to the *Equivalents* (pls. 35–40)? A question that persistently returns to my mind is whether each of these cloud studies is interchangeable with any other or whether some are truly more significant than others. Did he think of them as being like bricks, with each one interchangeable with the one next to it, in keeping with the word *equivalent?*

JS: Well, if he thought they were equal to each other, he's out of his skull! Because they're not. Some of them are wonderful, and some of them are really tedious! This (pl. 40) is a glorious picture.

WN: It's hard to imagine that this remarkable image could have been "found" rather than "made." It wasn't as though Stieglitz had a battery of lenses for his Graflex camera. He didn't have a focal length going up to telephoto that would have helped him enlarge the subject on the film. In order to make a cloud study, he had to first find an extraordinary phenomenon—a short-lived one at that—and have it fit the shape of his film, because Stieglitz did not crop or enlarge his *Equivalents.*

JS: With a Graflex you start with the edge—that's the playing field. You're looking at the sky through this box, and the edge is what is given. And the sky is constantly changing, which is why you can't make these pictures with an eight-by-ten-inch

camera—because the edges are never in the right place! The clouds are moving, and sometimes they're moving rapidly. There are a few eight-by-ten-inch prints, some of the *Songs of the Sky*, for example, that are remarkable. But even the most beautiful one I can think of is quite static—a little sun in the middle, a little white cloud, and a gray patch.

SG: The eight-by-ten-inch cloud negatives all date from the first year of the series— 1922. The reason there are so few of them is because it was too hard to point the eight-by-ten-inch camera directly up.

When I first visited Lake George, I went back up on the hill where the farmhouse used to be. The day I was there, the clouds just rolled in over those hills and mountains, and I realized why Stieglitz photographed them. They come so quickly and seem very, very close. You don't see them coming from a long way away. They roll over the hill and down the lake, and then they're gone. And you can understand why a man who was approaching sixty, and whose heart wasn't as good as it had been, started to photograph those clouds.

JS: Clouds. I'm really impatient with Edward Weston when he says, "My peppers have nothing to do with the peppers of seed catalogues." Why don't they? If you took Weston's peppers and put them in seed catalogues, why wouldn't that make the seed catalogue that much more wonderful and interesting and informative?

I don't understand the position that it's either got to be a cloud or a symbol, but it can't be both. In fact, if it's really an effective symbol, it's effective because it's something else too.

SG: I think Stieglitz would have said, "These are photographs of clouds, but they express emotional states that I have." I don't think he would have denied the specificity of what he was photographing. The first title was *Music: A Sequence of Ten Cloud Photographs.*

WN: When did the association with music disappear? Music was important to Stieglitz all of his life, and these seem to be the closest to a musical counterpart. But he dropped that after about 1924, when the titles became just *Equivalent.*

SG: The first title is *Music: A Sequence of Ten Cloud Photographs,* also called *Clouds in Ten Movements.* That was the title he gave to the first ten photographs that he took in 1922 of clouds, which were all eight-by-ten-inch views. And most of them have the line of the Lake George hills in them.

Then in 1923 he started using the four-by-five-inch Graflex camera and began, on the whole, pointing the camera up to the sky. From 1923 to 1925 they were called *Songs of the Sky.* And sometime in 1925 he started using *Equivalent.* In 1927 he titled a few *Equivalents,* using the word in its plural form.

EG: Somehow, whenever I saw these, even from the earliest, and I immediately felt that the picture was upside down, I would get irritated. Because it's terrific just the way it occurred—just let it be the way it was.

JS: You have to be reminded that he's there.

SG: Yes, that Stieglitz has an active hand in all of this.

EG: He destabilizes my relationship with nature. And I don't like anyone doing that!

SG: But Stieglitz would say he was destabilizing your relationship with nature in order to have you think less about nature, not to deny that it's a photograph of a cloud, but to think more about the feeling that the cloud formation evokes.

JS: What this does is to bring the surface of the paper right up to the frame, so that the top of the picture is back in deep space and the bottom of the picture is fastened right to the edge of the frame. And I think that's the wrong thing to do, because to me it seems an interruption in the interior vocabulary of the picture.

WN: But there's also another reason, and it has to do with why he started making these pictures in the first place. He told us he started making the *Equivalents* because he was accused of hypnotizing his portrait subjects and therefore intervening in their natural state. The problem is, when he willfully shifts the horizon, changes the direction of the picture, he is intervening against nature in much the same way that people accused him of doing in the portraits.

SG: If Stieglitz exhibited the *Equivalents* only in series, and we don't see them in

series, can we really understand them? How can we speak about these things if we don't see the whole and only pluck out one thing?

JS: But that's the way we see the entire history of art—the entire history of history! Not only because otherwise we wouldn't have time for it, but because most of the parts have been lost, destroyed. After all, if we look at Masaccio's *The Tribute Money*, we don't worry about whether Masaccio would want us to see this image out of the context of the church for which it was painted. And what if we're not true believers?

SG: But that is a different situation, because we know the story behind it. If we saw Barnett Newman's *Stations of the Cross*, and we saw only one station, would we have the same understanding of that whole work?

JS: I frankly don't think Newman's *Stations of the Cross* have much to do with the stations of the cross. But I think they have a lot to do with Modern painting, and those are the terms that I have looked at them in. Say there were only ten, so he had to call them *The Ten Commandments*—I think I would have looked at them in very much the same way.

SG: But what I was saying about the *Stations of the Cross* wasn't about its title. Suppose Newman had called the series *From A to Z*. Would we understand what *From A to Z* was supposed to be about if we only looked at one of them? That's what I see here. If this is part of a group of five *Equivalents*, and we see only one, do we really understand that one or have any sense of how Stieglitz might have wanted us to see it?

JS: But, as Minor White did, Stieglitz put pictures in different sequences. How do we know that there weren't other sequences that were somehow lost?

SG: There were.

JS: So our knowledge of his intention is imperfect. In fact, our knowledge of his intention is secondary to our appreciation of the work. We go to the work with whatever we're born with and have developed in the meantime that we can offer the work, in order to try to create some grounds for understanding. We cannot say

that we must understand the artist's intention before we can understand or appreciate the work, because in most cases we don't have any notion of what it was.

WN: Since it is getting late in the day, let's turn our attention to the Shelton images (pls. 41–43). They are in many ways directly opposite the cloud studies in their underlying idea. *From the Shelton Looking North* (pl. 41) seems to have one foot in *Picturesque Bits of New York.* In the foreground is an older building, in the middle ground is a skyscraper, and in the background is a building under construction. The progression from foreground to background seems to be a kind of panorama of New York history and not a philosophical rumination.

SG: I think this is one of a group that Stieglitz made in 1927, while he was still at The Intimate Gallery.

EG: This doesn't even feel like a Stieglitz to me. Not that it hasn't got every right to be. We were talking earlier about the problem when somebody makes a bad picture. I don't think it's ever the museum's problem that somebody made a bad picture. They are just entitled to do that. It's perfectly all right.

WN: I think museums are obliged to preserve the context of masterpieces, the working materials that reveal how a masterpiece came into being. *From the Shelton Looking North* is just that—a stepping-stone to *From My Window at the Shelton, North* (pl. 42).

JS: Where was the Shelton?

SG: Lexington Avenue and about Forty-ninth Street, right by the Waldorf-Astoria. It's now another hotel.

WN: These pictures get us back to Stieglitz's obsession with the duality of light and shadow, with brilliant light on the facade, and then these deep shadows. And yet, we don't think of these as technically virtuosic pieces. They are deeply emotional—records of a part of New York that Stieglitz obviously loved enormously. They are different from practically everything he did, except perhaps some of the New York street scenes of thirty years before.

SG: I think these are some of the most brilliant and sad photographs that I have ever seen. I think of Stieglitz sitting there at An American Place or at the Shelton Hotel, and he's so removed from it all.

JS: Absolutely. Looking down from the top of the cliff into this crazy city that he doesn't understand anymore, that he's lost contact with. He deals with that shadow (pl. 43) in a completely different way now than he did when he was young. You can't see into that shadow. It's a shape now. In the early days he always dealt with that kind of thing as a space. But here he deals with it as a shape—sharp, cutting, jagged, unfriendly, and threatening—and with that beautiful little piece of white! A photographer who has a genuinely original sensibility plus courage comes to a point in his or her career when he can say: "I don't have to do it that way. There's another way to do it. There's another vocabulary here in this family of techniques and this instrument. I can do it differently." And this is one of those moments—to use more than half the picture, which has virtually nothing in it at all, as just a shape, but it has to be an expressive shape, it can't just be amorphous black. It has to persuade you that it relates to the world, even if it's being treated as a shape.

SG: I see many of these later pictures, particularly the views looking north from An American Place, as having some of the sheer delight in form and chaos that you find in Mondrian's *Broadway Boogie-Woogie,* for example. At the same time, they have a huge emotional overlay of Stieglitz as an old man, sitting at the Shelton Hotel or An American Place, alone and looking out his window, and being fascinated with that ever-changing picture of New York City—changing not only because of the skyscrapers being built but also more subtly through the play of light on the buildings.

CH: For me, these exemplify the way in which he was able to make pictures of the city that were also formal studies and personal images. It's hard to look at the black and not think of him as an old man at the end of his working career, thinking about the darkness. At the same time, in each of the pictures a building is being built.

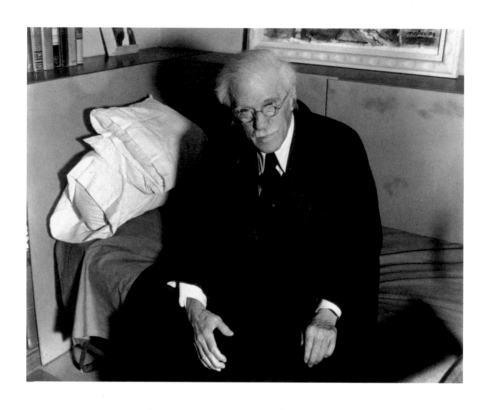

Weegee. *Alfred Stieglitz,* 1945.
Gelatin silver print, 26.9 × 33.9 cm.
84.XM.190.4.

SG: It was that sense of change he was attracted to. What's interesting is that when the buildings stopped being built due to the Depression, Stieglitz stopped photographing the city.

WN: Emmet, do you respond to these pictures as strongly as you do to Stieglitz's other work?

EG: I think it's unfortunate that the cloud pictures get tagged with the label of *Equivalent* and that these are left out. Because these could just as well be titled *Music* or *Equivalent*. It's hard to imagine any picture that isn't equivalent, just as it's hard to imagine any picture that isn't pictorial.

I cannot think of any picture lonelier than this one, with the little white spot. It's the same emotional tone that he struck when he came back from Europe in 1890, in his first city pictures. Here, though, it's expressed in a Modernist idiom. For me, the cloud pictures are not deeply moving—the clouds, which are already moving by themselves, are tremendously reduced. But this I find extremely moving.

In some ways I think we can talk about these pictures the way we would about a musical score—about the proportionality of pitch and its placement within the frame. Frederick Sommer and I were once talking about one of his desert landscapes that had a cactus in the middle, and he whispered, "That's the conductor leading the orchestra." For me, this little bright patch is like the conductor, leading an orchestra of darkness.

I'm not sure we would talk about these images the way we do if we weren't so aware of the importance of Stieglitz's whole life. I've always been attracted to groups of Stieglitz's pictures, but the mortar between all those images was the ideas, the love of European art that he didn't even understand. That for me is much more important than some of his photographs. I love that Stieglitz trusted Steichen to send him art from Paris. To me, that is absolutely intuition in action. And so, when he talks about the idea, the center behind the center of the target, the unnameable that rests behind the name of the thing, I feel that deeply. You can't just hand that to somebody, and you can't make a code of it. It has to be a personal experience.

I feel these pictures too. But the clouds are just not the important ones for me. And the *Equivalent* idea I think should apply to all pictures. I think John is right when he says that we should be able to come to any picture, and if there's something there for us, it should open up into us. We should open up a new picture.

WN: One of the people who was most impressed by the *Equivalents* was the sculptor Carl Andre, who dedicated one of his earliest series of sculptures to Stieglitz and claimed that he was one of his most important precursors. But just as many people have had trouble giving themselves over to Andre's Minimalist sculptures, I think the *Equivalents* can be difficult to enter fully. I have always found them very interesting, but I have never been able to say why. For me, the *Equivalents* resist any attempt to give them added meaning through words.

EG: As I sit with these pictures from the Shelton, I realize that the city projects a photogram of itself onto itself. This shape is like an autophotographic shadow of the city, a projection of its form. Throughout his life, Stieglitz had an incredible kinetic awareness, shape awareness.

CH: We have skipped over an awful lot today. There are so many threads of ideas that have wandered through this conversation that I have been eager to chase down and capture, but we haven't had time to do so. And we have obviously skipped over whole groups of work, not to mention activities of his rich life.

At one time there was a strong reaction against Stieglitz; he was seen as old hat and a negative force in photography. What is his legacy for us now? How active is it? Is he more interesting as a historical figure, a great, self-confident, self-inventing early American Modernist? We have obviously found interesting many of the pictures we've looked at here. But for photographers today, is there much to find in his example or his pictures?

EG: Rilke says something like, "The act you're about to commit, would that act be favorable to a woman who is about to give birth?" I wonder if his portraits of O'Keeffe still stand up to the scrutiny of women—and then you might add, "who are about to give birth."

SG: I think his portraits of O'Keeffe are problematic now for many women photographers.

WN: The Getty recently held an exhibition called *Two Lives,* where some of the O'Keeffe pictures were shown. The response to them from women was extraordinary, in terms of their sense of identification with what they saw. I was astonished at the power that those pictures had to communicate to general audiences. Now, whether they communicate to photographers or not, I am not sure.

SG: But are those people responding to O'Keeffe or to Stieglitz?

WN: Of course, we don't know.

JS: I've found that as a photographer and a curator I've had to discipline myself and forget Stieglitz in order to be fair to the work. I don't find him an altogether sympathetic character. There is something too Wagnerian about him, occasionally a kind of pompous Teutonic posturing that I can't stand.

But if I tell myself to be quiet and go to the work, there are marvelous pictures from throughout his career that even today are very nourishing. For students, though, it's often hard to get at, because he is surrounded by his myth, which in a sense has tended to put the work beyond criticism. This is a terrible disservice to any artist, especially a great artist.

With any artist worth our serious attention we don't expect to get ultimate critical understanding. But to get somewhat closer to this with Stieglitz, it would be useful to know what he said and when, as opposed to what somebody remembered him saying. In his own writings he tends to be saner, more skeptical; his thinking often seems fuller of fresh air than what he is reported to have said.

SG: I think, too, that if we look beyond the few images that we see again and again, and look more broadly at his work, we start to see things that are extraordinary in their freshness. If we look beyond the few that have been reproduced, we find a different person.

WN: Thank you, Sarah. What a fitting note on which to close this dialogue.

Chronology

1864

Alfred Stieglitz is born January 1 in Hoboken, New Jersey, to prosperous German immigrant parents, the first of six children.

1871

Family moves to New York City (14 East Sixtieth Street).

1879–81

Studies at the College of the City of New York.

1881–82

Stieglitz's father retires from business and takes the family to Europe for five years of residency in different cities. Stieglitz attends the Realgymnasium, Karlsruhe, Germany, and then studies mechanical engineering at the Technische Hochschule, Berlin.

1883

Makes first photographs. Changes course of study from engineering to photochemistry under tutelage of Professor Hermann Wilhelm Vogel, a highly reputed photochemist. Conducts now-lost experiments in photographing with artificial light.

1886

First year for which there are surviving prints. Leaves Technische Hochschule. Becomes avid walker and spends summer in Italy, Bavaria, and Switzerland, resulting in first important body of photographs. Takes part in first club and magazine competitions. His father acquires Oaklawn, the New York estate on Lake George where Stieglitz will cumulatively spend more time than at any of his personal residences.

1887

Wins first prize for his photographic genre study *A Good Joke* in the Holiday Work Competition sponsored by the London magazine the *Amateur Photographer* (awarded by Peter Henry Emerson). This is the first of the more than 150 medals and awards he will receive in his lifetime. British and German periodicals begin publishing his images.

1888

Emerson invitation to translate into German his forthcoming book *Naturalistic Photography for Students of the Art* (1889). Stieglitz spends first summer at Oaklawn.

1889

Attends monumental Vienna exhibition celebrating the fiftieth anniversary of the announcement of photography, where he sees work by the pioneers of the medium: Louis-Jacques-Mandé Daguerre, William Henry Fox Talbot, and Julia Margaret Cameron; his own photographs are included in the Berlin anniversary exhibition.

1890

Returns to New York to attend the funeral of his sister Flora and is urged by his family to repatriate. Becomes a partner with Louis Schubart and Joseph Obermeyer, his Berlin

roommates, in the Heliochrome Company (later the Photochrome Engraving Company) in New York; one of its clients is the *Police Gazette.*

1891

Joins the Society of Amateur Photographers.

1892

Acquires first four-by-five-inch hand-held camera and uses it to photograph New York cityscapes.

1893

Marries Emmeline Obermeyer (b. 1873), the sister of his business partner Joseph Obermeyer. Becomes chief editor of *American Amateur Photographer.*

1894

Alfred and Emmeline make honeymoon trip to Venice, Vienna, Munich, The Hague, Paris, and London. Exhibits at the First International Salon at the Photo Club of Paris. With Rudolph Eickemeyer, Jr., first Americans elected to the Linked Ring in London, an association of Pictorialist photographers.

1895

Leaves Photochrome Engraving Company to concentrate on photography.

1896

Resigns editorship of *American Amateur Photographer.* Becomes vice president of the merged Society of Amateur Photographers and New York Camera Club, known as the Camera Club of New York.

1897

Founds and directs *Camera Notes,* the journal of the Camera Club. Publishes photogravures by Pictorialist photographers whom he champions and begins to form a

collection of photographs. *Picturesque Bits of New York,* a portfolio of twelve photogravures, is published by R. H. Russell in New York.

1898

Daughter, Katherine (Kitty), is born September 27. Exhibits at the Munich Secession. In collaboration with Joseph Keiley, devises method of developing platinum prints using glycerine.

1899

First solo retrospective exhibition at Camera Club, consisting of eighty-seven prints from the period 1885 to 1899.

1900

In London, exhibits series of photographs of his daughter entitled *Photographic Journal of a Baby.*

1902

Resigns from *Camera Notes* and, in collaboration with Edward Steichen, founds the Photo-Secession in conjunction with an exhibition, *American Pictorial Photography,* at the National Arts Club, New York.

1903

Begins editing and publishing *Camera Work.*

1905

Becomes a member of the Royal Photographic Society, London. In New York, opens The Little Galleries of the Photo-Secession, later known as 291 (for its location on Fifth Avenue), in collaboration with Steichen, who becomes Stieglitz's eyes in Paris for several years.

1907

Creates *The Steerage,* but does not make it public until 1911. Works with Lumière autochromes while in Europe with Steichen,

Frank Eugene, and Heinrich Kuehn and later exhibits the results. Does series of nude studies in collaboration with Clarence H. White. Georgia O'Keeffe (1887–1986) studies at Art Students League, New York.

1908

Stieglitz is expelled from the Camera Club and, after being reinstated, resigns permanently.

1909

Father dies. Summer trip to Europe affords Stieglitz meetings with Matisse and Leo and Gertrude Stein. Exhibits at International Union of Art Photographers in Dresden.

1910

Organizes the *International Exhibition of Pictorial Photography* at the Albright Art Gallery, Buffalo, New York, which is the most ambitious American photography exhibition of its time. Begins to show mostly painting and sculpture at 291.

1911

Picasso's first solo exhibition anywhere is shown in April at 291.

1913

At 291 exhibits thirty selected prints dating from 1892 to 1911. Purchases Kandinsky painting from the Armory Show.

1916

Meets O'Keeffe.

1917

Photographs O'Keeffe for the first time in June. *Camera Work* terminates with its fiftieth issue, on Paul Strand. Closes 291.

1918

Leaves wife and daughter. O'Keeffe moves to New York and lives with Stieglitz in the studio of his niece Elizabeth Davidson.

1920

Stieglitz and O'Keeffe move in with Stieglitz's brother Leopold at 60 East Sixty-fifth Street.

1921

Solo retrospective of 145 prints from 1886 to 1921 at the Anderson Galleries, New York.

1922

Edits and publishes *MSS* magazine (through 1923) with Paul Rosenfeld and Herbert J. Seligmann. Makes first cloud studies. Begins to use negative film packs, permitting exposures in rapid sequence with Graflex. Mother dies.

1923

One-man show of 116 prints from 1918 to 1923 at the Anderson Galleries.

1924

Exhibits sixty-one prints, mostly from 1923, with fifty-one paintings by O'Keeffe at the Anderson Galleries. Museum of Fine Arts, Boston, acquires twenty-seven Stieglitz photographs. Moves to 35 East Fifty-eighth Street. Divorces Emmeline; marries O'Keeffe.

1925

Opens The Intimate Gallery at the Anderson Galleries (489 Park Avenue). Moves with O'Keeffe to suite 3003 of the Shelton Hotel (Forty-eighth and Lexington).

1928

Twenty-three of Stieglitz's prints are given to the Metropolitan Museum of Art by David Schulte and other anonymous donors.

1929

Closes The Intimate Gallery after approximately twenty exhibitions of the work of Strand. Opens An American Place at 509 Madison Avenue, which, through 1946, will present approximately seventy-five exhibitions